JOSÉ ANTONIO HERNÁNDEZ-DIEZ

Organized by Dan Cameron & Gerardo Mosquera

ESSAYS BY:

Gerardo Mosquera

Monica Amor

Dan Cameron

Jesús Fuenmayor

HERNÁNDEZ-DIEZ

José Antonio Hernández-Diez
Published in association with the
exhibition *José Antonio Hernández-Diez*.

Co-curated by Dan Cameron,
Senior Curator and Gerardo
Mosquera, Adjunct Curator—
New Museum of Contemporary Art

José Antonio Hernández-Diez is made
possible by generous grants from
the National Endowment for the Arts,
Elizabeth Firestone Graham
Foundation, Colección Patricia Phelps
de Cisneros, Caracas, and from
Rosa and Carlos de la Cruz.

The accompanying catalogue is made
possible by Colección Patricia Phelps
de Cisneros, Caracas, and the Penny
McCall Publication Fund at the New
Museum. Donors to the Penny McCall
Publications Fund are James C.A.
and Stephania McClennen, Jennifer
McSweeney, Arthur and Carol
Goldberg, Dorothy O. Mills, and the
Mills Family Fund.

Exhibition Schedule
SEPTEMBER 13–NOVEMBER 17, 2002
PALM BEACH INSTITUTE
 OF CONTEMPORARY ART
Lake Worth, Florida

JANUARY 24–APRIL 6, 2003
SITE SANTA FE
Santa Fe, New Mexico

JULY 8–SEPTEMBER 21, 2003
NEW MUSEUM OF CONTEMPORARY ART
New York, New York

Published by the New Museum
 of Contemporary Art
Copyright © 2002 New Museum
 of Contemporary Art, New York
All rights reserved

Copyedited by Tim Yohn

ISBN: 0-915557-84-3

Distributed by D.A.P.

FRONT & BACK COVER:
Marx, 2000
C-print photograph
82 5/8 x 63 inches (framed)
Courtesy of the artist

INSIDE FRONT & BACK COVER:
Sin título (Untitled), 1996
wood, roller-skate wheels
86 5/8 x 9 7/8 x 3 7/8 inches
Coleccíon Ignacio e Valentina Oberto, Caracas

ESSAYS
MP3 Files (work in progress)
glicee prints
grande mp3 n° 8 vol.2, 2002 (pg. 9)
pequeño mp3 n° 8 vol.1, 2002 (pg. 13)
pequeño mp3 n° 9, 2002 (pg. 17)
Pantalla 3, 2002 (pg. 21)
Pantalla 4, 2002 (pg. 27)

PHOTOGRAPHY CREDITS:
Galeria Fortes-Vilaça, Sâo Paulo
Galería Elba Benítez, Madrid
Sandra Gering Gallery, New York
Galería Estrany- de la Mota, Barcelona
Centro Galego De Arte Contemporánea (CGAC), Santiago de Compostela
Galería Enrique Guerrero, Mexico
Galería Javier López, Madrid
Luis Asin (pgs. 92,93, 94, 95)
John Bessler (pgs. 42-43, 44-45, 46, 47, 48-49)
Rita Burmester (pg. 90)
Eduardo Muñoz (inside front and back cover)
Xenaro Martínez Castro (pgs. 72-73, 74, 75)
Karl Peterson (pgs. 50-51, 52, 53, 54-55)
Javier Compano (pg. 91)

This survey of José Antonio Hernández-Diez's work grew out of discussions with Gerardo Mosquera that began in early 1996. Hernández-Diez is an artist whose work both of us were particularly enthusiastic about at the time, and the intervening years have seen a growing recognition of his accomplishments throughout the international art community. In the meantime, this exhibition has also metamorphosed somewhat, so that its perspective is enhanced considerably by the addition of certain key works produced during the past five years.

For his patience and hard work on the preparation of this exhibition over the course of six years, and for his unflagging good humor throughout a series of unfortunate delays, I am deeply indebted to the artist, José Antonio Hernández-Diez. Another important artistic talent that deserves mention here is that of catalogue designer, Paul Carlos, whose insight into Hernández-Diez's work has resulted in an interpretive tool that is also a beautiful object in itself. Along with the design and the artworks on view, this publication would also not have been possible without the sensitive and insightful essays produced by art historian Monica Amor, art critic Jesús Fuenmayor, and my New Museum colleague and co-curator, Gerardo Mosquera.

A considerable amount of research has gone into the selection of works for the exhibition, as well as for the images used in this publication, a task that would have not been possible without the enthusiastic support of the artist's galleries. For this, an enormous thank you is owed to Galeriá Elba Benítez, Madrid; Galeriá Estrany-de la Mota, Barcelona; Galeria Fortes-Vilaça, São Paulo; and Sandra Gering Gallery, New York.

Also, the lenders to the exhibition, whose names appear elsewhere, have shown great support for this project by permitting much-loved works from their collection to be in our safekeeping during the exhibition tour.

The New Museum is extremely proud that *José Antonio Hernández-Diez* could be shared with two sister institutions that in relatively short spans of time have become true innovators within their field. In addition, we are personally delighted that Louis Grachos of SITE Santa Fe and Michael Rush of Palm Beach ICA will be presenting Hernández-Diez's work in their cities, thereby making it possible for a much broader range of viewers in the U.S. to appreciate his contribution to the art of our time.

My colleagues at the New Museum have been incredibly supportive during the long gestation of this exhibition from concept to reality, and no one more so than Director of Exhibitions Management John Hatfield, who has overseen this exhibition's development with precision and enthusiasm. Curatorial Fellow Johanna Burton's aid with organizing catalogue essays and loans of artworks has been thoroughly indispensable, as has Associate Curator Anne Ellegood's persistent organizing work for the exhibition tour. Naturally, the constant encouragement of Director Lisa Phillips and Deputy Director Dennis Szakacs provide the best possible motivation for making the effort to keep aiming higher with each New Museum exhibition.

Finally, none of this would be possible were it not for the timely award of exhibition presentation support from the National Endowment for the Arts, and of generous grants by individuals and foundations, including the Cisneros Family Foundation, and Rosa and Carlos de la Cruz. We are especially grateful for their generosity.

Dan Cameron

ACKNOWLEDGMENTS

A museum overview of the work of José Antonio Hernández-Diez has been long overdue in this country. Although he has exhibited widely around the world, notably at the most recent Carnegie International, until now Hernández-Diez's work has not been seen in depth in the U.S. At the same time, his name has long been associated with a generation of artists who emerged in the early 1990s with an unusual fusion of media technology, social critique, and dark humor, effectively challenging the accepted parameters of Latin American art. Although this exhibition comes out of Gerardo Mosquera's and Dan Cameron's involvement with his work nearly a decade ago, some of Hernández-Diez's artistic motifs from the early 1990s—mortality and the role of the machine in the decline of quality of life—seem especially pertinent at the present moment.

Hernández-Diez is no stranger to the artistic preoccupation with the human body that was characteristic of the art of the early and mid-90s. His obsession with the physical stuff of existence, whether flesh and blood or imaginary, should come as no surprise considering that he is of the same generation as Janine Antoni and Matthew Barney. While some aspects of Hernández-Diez's work, such as his sculptural employment of refried pork or his large photos of cheaply made sneakers, may seem exotic, they form part of a complex vocabulary derived from the artist's deep fascination with the ordinary as a mask for the truly bizarre.

José Antonio Hernández-Diez's exhibition is the latest in a groundbreaking series of New Museum programs investigating contemporary art from the Caribbean and South America—itself part of a larger commitment to art in its global manifestations. Following on the (now) historic surveys of Ana Mendieta (1987) and Alfredo Jaar (1992), the New Museum a few years ago embarked on a more intensive examination of the field, including retrospective exhibitions of Eugenio Dittborn (1997) and Cildo Meireles (1999), as well as *Unland* (1998), a gallery-scaled installation work by Doris Salcedo (in collaboration with SITE Santa Fe). We were also co-organizers (with the Wexner Center for the Arts and the Kölnischer Kunstverein) of the exhibition *Helio Oiticica: Quasi Cinema*, which was shown at the New Museum from July to October 2002. During the past six years, the New Museum has also presented new site-specific installations by important emerging artists from the region, including Los Carpinteros, Teresita Fernández, Rivane Neuenschwander, Juan Maidagan & Dolores Zinny, and Maria Fernanda Cardoso.

Because Hernández-Diez is at a mid-career stage, it is particularly important to have this opportunity to present some of the key works in his development to a public in New York, Palm Beach, and Santa Fe. I would like to thank my colleagues Michael Rush, Director, ICA Palm Beach, and Louis Grachos, Director, Site Sante Fe, for hosting the exhibition at their institutions.

Dan Cameron's and Gerardo Mosquera's selection, texts, and installation have been excellent, John Hatfield's expert stewardship of the tour and checklist is superb as always, and Johanna Burton's and Melanie Franklin's management of the catalogue has been outstanding. Exhibition support from the National Endowment for the Arts, Elizabeth Firestone Graham Foundation, Colección Patricia Phelps de Cisneros, Caracas, and from Rosa and Carlos de la Cruz is deeply appreciated. José Antonio Hernández-Diez is an extremely inventive and challenging artist and we are grateful for the vision and commitment these patrons have shown in supporting this important contemporary work

Lisa Phillips

ARROZ CON MANGO:

WHEN JOSÉ ANTONIO HERNÁNDEZ-DIEZ WAS a child, he told his father: "Dad, when I grow up I want to be a doctor." "Oh no, that would be terrible!" his father answered: "You must be an artist!" This anecdote is a key to the artist's singularity. It sheds light not only on his early installations incorporating sophisticated medical equipment, but also on his distinctive artistic stance. Being "forced" to become an artist gave Hernández-Diez a natural capacity for saturating his work with elements and contents from very diverse sources, and for impelling it in other, frequently surprising, directions. The anecdote about his father, told by the artist many years ago at a panel discussion in Bogota, refers to the displacement of paradigms typical of his work: Hernández-Diez is constantly engaged in shifting everything in terms of place, role, and sense.

It is true that after Duchamp, in general terms these kinds of shifts are what art is about. But Hernández-Diez's distinctive sensibility is the consequence of an all-encompassing meta-artistic condition moving from life to art, which at the moment of making "real" art provides a platform for spontaneous responses. The result, even if it fits into the usual contemporary international art "label," is a certain personal oddity that often puzzles audiences and is perhaps why the artist has not yet received sustained international recognition. Radical displacements and recombinations of meanings, frameworks and culturally disparate components, fracturing of expectations, and other unsettling traits all reflect a sort of "outsider" way of dealing with art. Hernández-Diez is the strange case of a professional artist who makes art as if he were not making art. José Antonio's father was no art lover: he wanted his son to become an artist because the boy's playful and sensitive personality would make him incompetent as a doctor. If the son finally did become an artist, it was not only because art gave him a space for experiment and fantasy, but more than anything else, it gave him the possibility of doing whatever he wanted to do.

Hernández-Diez's art entails complex and playful interactions among postconceptualism, vernacular culture, humor, technology, international language, symbolism, social issues, minimalism, and other ingredients not usually cooked together in mainstream practices. Some of these elements facilitate an international reception; others hamper it. This shows how urgent it is for us to expand our understanding of an increasingly internationalized art world. The artist once gave the title *Arroz con Mango* (*Rice with Mango*) to one of his pieces. This Spanish idiom connotes a bizarre combination and, by extension, refers to disorder. However, unexpected arrangements do not necessarily mean confusion. They can be the plausible answers to new visions and interactions. Hernández-Diez's art might be a tasty and nutritious *arroz con mango*, indispensable in dealing with the complexities of our time.

There is a major tendency nowadays to dissolve art into real life, but not through the kind of conscious effort undertaken by the Russian Constructivists or, in different ways, by Fluxus or Joseph Beuys. In those cases, art in the end was stripped of fetishism in appearance, while its "aura" prevailed in the conceit that it could transform life. What many young artists from different countries are doing today –whether cynically or sincerely– is to identify as art certain activities in which the artistic element is so diminished as to be indistinguishable from daily life. This does not mean

GERARDO MOSQUERA

representing the triviality of quotidian existence, as in Bruce Nauman's work, but rather enacting it. These practices are, in themselves, either banal or insignificant, or are at the point of turning into something other than what is usually understood as art. Hernández-Diez relates to this tendency only in terms of spontaneity and the role that quotidian and unexpected elements play in his art. His procedure is rather the opposite: instead of identifying art with common life, he keeps art separate as an activity of producing specific objects and events to be exhibited; in so doing he uses art as a playground.

Play is an essential concept here, for a sense of the ludic pervades all of Hernández-Diez's works. Sometimes his pieces summon the audience to play, as in his untitled 1997 piece (formerly titled *Arroz con Mango*) in which you are asked to hit a table with a baseball bat; the table reacts, according to where you hit it, turning on and off different recordings of mariachi and other Latin American vernacular music. In other works, playing is a thematic component, as in Hernández-Diez's pool table equipped with a mechanical arm for hitting pool balls, or in his pieces involving skateboards. These last express a certain juvenile, adolescent strain in Hernández-Diez's poetics, which goes to the very foundations of his work. Art here provides a license for personal games, *jouissance*, and fantasies.

Other artists like Miguel Calderón and Joshua Okon push this aspect even further, using art as an excuse to realize their reveries and to trigger otherwise unavailable experiences. In their case it is the action carried out "in reality" in order to create "the piece" which provides the work's artistic significance. The aspect of process is not as important as how the artists themselves experience the making of the work and the manner in which they share this with the audience. In some works by Hernández-Diez, however, knowledge of the work's process adds new meanings. The installation *Que te rinda el día* (*Have a Productive Day*), 1995, consists of furniture bearing what seem to be bite marks from a giant. At first sight, the piece communicates tension and creates a fantastic new myth. But when you realize that the furniture was actually bitten by a mechanical press adapted by the artist, a performative aspect comes to the forefront. It relates to an ongoing, fanciful relationship between technology and the body, opening a new avenue of meaning. Both lines of discourse interact, enhancing the work's complexity and fascination.

Calderón's or Hernández-Diez's personal use of art does not mean that their attitudes are not thoughtful and professional, or their artistic results limited or unsophisticated. On the contrary, they open interesting new perspectives. After all, play has always been a very serious business. Hernández-Diez's approach is fruitful in distinctly artistic terms, by introducing fresh imaginative factors without enforcing strict intellectual boundaries. This helps make contemporary art less severe and boring–and more amusing. Amusement is rare in today's art scene, inflated as that scene is with self-referentiality, repetition, the evaporation of meaning, the use of real time, minimalization, the cult of the almost imperceptible gesture, the increase in trivial themes, and the spread of practices that have acquired a tedious character. Fortunately, the opening of new art circuits around the world is helping diffuse more diversified artistic practices.

As we have seen, Hernández-Diez's work frequently involves

1 Meyer Vaisman, "José Antonio Hernández-Diez," in *Regarding America* (Bogotá: Biblioteca Luis-Ángel Arango, 1992), 33. See also *Ante América* (Bogotá: Biblioteca Luis-Ángel Arango, 1992), 119.

technology: video monitors and projectors, sensors, sound equipment, surgical devices, etc. In some cases, technology is not a means, but a significant constituent of the work. This is evident in his early pieces with medical equipment, in which these devices and their functions were the work's main component. *Sagrado Corazón Activo* (*Active Sacred Heart*), 1991, is a good example. It consists of a cross-shaped Plexiglas box containing an actual cow heart connected to a pumping device that keeps it "alive." However, technology is never the "star" in Hernández-Diez's work, which does not orient itself toward high-tech poetics. Even in a piece like the one described, where technology plays a prime role, it is always situated in what we could call an anti-technological setting, dominated by vernacular culture, religious traditions, or childish playful stances. *Sagrado Corazón Activo*'s main reference is to the image of the Sacred Heart, an icon of popular Catholicism familiar all over Latin America, in which Jesus Christ appears displaying his heart as if it were an X-ray picture. The work was part of the artist's impressive first one-person exhibition in 1991 in Caracas, where he presented what he called "a new Christian iconography." A sister piece included in the show was *Sagrado Corazón Vídeo* (*Video Sacred Heart*), 1991, where the real heart was replaced by a monitor showing a videotape of a beating heart. Both works, like all the others in the 1991 exhibition, had an aseptic aspect that combined minimalism with a laboratory look. The pieces and the way they were installed conveyed a scientific environment that contrasted with the usual baroque altar settings in which popular Catholic subjects have been rendered by many artists. The formal technological aspect thus balanced the strong religious content. Meyer Vaisman commented at the time that the exhibition merged opposites "the religious and the scientific, the believer and the skeptic, into a sinister view of Christianity that has a particular Latin American slant."[1]

The meaning of these works is intricate, mixing philosophical, religious, and vernacular issues in a provocative way. Even an extreme case like *Lavarás tus pecados* (*You Shall Wash Your Sins*), 1991, in which a washing machine installed in another cross-shaped structure endlessly launders a replica of the Shroud of Turin, goes beyond sarcastic implications. However, Hernández-Diez's "new Christian iconography" is clearly a product of the ironic treatment of technology characteristic of his art, which became stronger in later works. A mechanical arm playing pool or a pneumatic press that bites furniture mimicking a gigantic human mouth constitutes childlike, surprising uses of technology that eschew functionality in favor of new imaginative and playful applications.

This approach could be seen as a critique of an age when technology is coming to dominate the human condition more and more. This is the result of the increasing intelligence of the devices that determine our environments and our increased dependency on them. Hernández-Diez symbolically turns this situation around by transforming what could be called the technological condition. His work does not reject technology in favor of a pristine human essence; rather, it hints at the subversive possibility of frolicking with technology.

We could perhaps divide the artist's work into two not rigidly defined periods. The earlier period was inclined to social and cultural critique, a prime example being *In God We Trust*, 1991,

a video installation that projects footage of street riots in Caracas from a pyramid with an all-seeing eye on a monitor, a replica of the Masonic symbol on the U.S. dollar bill. This was one of very few works in Venezuela at the time that addressed the country's acute social problems, and it had a strong impact on the local art scene, bringing political issues to the forefront. In the second period, from the mid-1990s on, Hernández-Diez's work became more presentational, less symbolic and denotative, as in his untitled piece from 1998 consisting of one hundred TV-remote covers. Nevertheless, this division is rather superficial, because social and cultural concerns remain central to the artist's work.

Even a minimal piece like *Soledad Miranda*, 1998, carries a wide spectrum of meanings. The work consists of gigantic fake fingernails that at first sight look like oval plastic geometric sculptures. The artist installs them in different configurations, sometimes together with large pieces of sandpaper. The title alludes to a famous Venezuelan "B" movie actress of the 1940s and relates—nostalgically and ironically—to mass culture icons and to feminine stereotypes through which Latin American culture was long represented. Among the many connotations the piece triggers is the Miss Venezuela competition and the myth of the country's women as beauty idols: Venezuela has won more Miss Universe competitions than any other country. The *"misses"* (as the pageant winners are called) became so popular that one of them even ran for president (she was not elected). In any case, the event has become a national sport, and it is broadcast internationally. If all these narratives can emanate from *Soledad Miranda*, it is because concentrating on a single minimal shape paradoxically gives the work an impressive connotative power, ranging from formalism to cultural critique to the fruition of kitsch. With the huge fingernails, the artist succeeded in creating a synthetic icon to rival the cross or the swastika.

Many contemporary artists involved in contexts affected by intense and complex social problems and contradictions have used art's potential for intricacy to expose and illuminate these situations. They have done so by utilizing art's poetic capacities, thereby pursuing an alternative to pamphlet, manifesto, or discursive essay. Mona Hatoum, Cildo Meireles and Doris Salcedo, who have all had one-person shows at the New Museum of Contemporary Art in New York, are also artists who work in this way. Hernández-Diez's art is not dictated by a political or cultural agenda, but the artist reacts to his environment in a very sensitive manner, and this determines his artistic discourse. Social criticism appears within a symbolic grid connecting it to religious, cultural, and vernacular contents. The interrelated video installations *Vas p'al cielo y vas llorando (You Go to Heaven and You Go Crying)*, 1992, and *La caja (The Box)*, also from 1992 but produced later for the *Ante América (Regarding America)* exhibition in Bogota, provide good examples. The first was inspired by the Andean peasant tradition of exhibiting the lavishly dressed corpse of a child on a decorated table before burial. According to vernacular Catholic beliefs, the dead child was considered to be an angel on its way to heaven. *Vas p'al cielo...*, with its delicate video projection on a transparent screen, achieves a strange balance of aesthetic impact, spirituality, irony, and necrophilia. *La caja* was a result of the artist's reaction to Bogota, where he was impressed by the *gamines*, the numerous

and violent street kids in the city. In this case the "angel" is a mischievous *gamín* videotaped by the artist. The installation includes boxes as a symbol of Colombian street children's main occupation: collecting paper and cardboard for recycling. Simultaneously tough, sarcastic, and poetic, the work connects the Andean religious custom with the frequent killing of street children in Colombia and other countries, highlighting the hypocritical and contradictory nature of society's response to their plight.

It has been said of Hernández-Diez's work that it confronts the polarity of cosmopolitanism versus localism. In fact, the artist has broken away from this postcolonial formulation and its barren predicament. Like many of his colleagues all over the world, Hernández-Diez is not representing his own difference but constructing a more diversified "international language" from his own context and experience. In his art, cultural or contextual components, even when important as references, act more within the works' discourse and poetics than in relation to their strict visuality. Context and culture are understood in their broadest definitions and are internalized in the creation of the work. Hernández-Diez's art, more than naming, analyzing, expressing, or constructing contexts, is constructed from them. He performs identity more than merely showing it—as is often expected of artists coming from so-called peripheral countries. This procedure corresponds to a global situation where, as Kobena Mercer puts it, "diversity is more visible than ever before, but the unspoken rule is that you do not make an issue of it."[2] Like other diverse contemporary practices, Hernández-Diez's work concurs in redesigning art's "international" language and simultaneously delves into personal obsessions and current "global" themes.

2 Kobena Mercer, "Intermezzo Worlds," Art Journal, vol. 57, no. 4 (Winter 1998): 43.

THE ABSENT, SPECTRAL, & GIGANTIC IN THE

...human life cannot in any way be limited to the closed systems assigned to it by reasonable conceptions.
GEORGES BATAILLE,
"The Notion of Expenditure."

THE WORK OF José Antonio Hernández-Diez is usually assessed in terms of rupture, a break with the pictorial and sculptural practices that dominated artistic production in Venezuela during the late 1980s. On closer look, however, one can recognize that Hernández-Diez's work, like that of his predecessors—Armando Reveron's performative pictorial process, Gego's drastic attack on sculpture via the paradoxical embrace and rebuff of the legacy of Constructivism, and more recently Claudio Perna's eclectic politico-conceptual practice—is indicative of the reversals and inconsistencies, the delays and affects, and the intrusions that shaped the malleable project of modernity in the periphery.

But at the end of the 80s, when Hernández-Diez started to exhibit his work, he faced a set of circumstances and situations unknown to previous generations. The economic, political, and social crisis afflicting Venezuela, which the oil industry had ferociously tried to disguise with the illusion of wealth, was obvious to all. The political farce in which the country was immersed ended with the riots of 1989 and an attempted coup d'état in 1992. It was "the end of the age of innocence," as curator Jesús Fuenmayor succinctly described the new cultural situation of the country.[1] And it was at this time that Hernández-Diez turned to the vernacular and the everyday to develop a sort of "low-tech" political pop that drew heavily on religion, technology, mass production, mass media, politics, and the human body.

But the body in Hernández-Diez's work is neither the perceptual body of the abstract environments created in the sixties and seventies (as in the work of Gego and Domingo Alvarez) nor the socially coded body tested and contested in the work of such disparate artists as Víctor Lucena and Claudio Perna. Instead, the body in Hernández-Diez's work is partial and absent, implied and marginal, monstrous and "other." If since "les années pop"[2] urban life has increasingly become identified with the commodification of all aspects of life (including art) and the absorption of the body and subjectivity into the dematerialized structures of the spectacle, the vernacular and media-oriented work of Hernández-Diez centers on the residual and wasteful bodily forces released by the dynamics of power of the commodity. The result is literally a "body" of work, an inorganic body, however, which explores the unpredictable dynamics of cultural, social, and political modernity in the subcultures of the global village.

The term subculture is applied broadly here. Generally designating the culture of a small group of people—in urban settings, instances of social digression from the mainstream order—subculture in Hernández-Diez's work is an open space of indeterminacy that weakens social conventions and expectations and the one-dimensional codes of communication. It is no wonder that critics have called the juxtapositions upon which much of his work is based absurd, surreal, fantastic, and mysterious. Morphologically, the work takes much from the assemblage techniques of the 1950s and 60s and the blatant theatricality of more recent installation art. Unexpected juxtapositions of ready-made objects and materials predicated on a surreal economy are

1 Jesús Fuenmayor, "The End of the Age of Innocence," *Poliester* (Winter 96/97): 26.

2 *Les Annés Pop* was the title of a summer 2001 exhibition on pop culture at the Centre Georges Pompidou, Paris.

WORK OF JOSÉ ANTONIO HERNÁNDEZ-DIEZ:

also paramount in the work of artists such as Rebecca Horn, Matthew Barney, and Gabriel Orozco. In the case of Hernández-Diez, however, estrangement is usually associated with a disfiguration of the object and/or the latent and repressed body in cultural representations of modernity and current discourses on textuality with its emphasis on the disembodied subject of post-industrial society.

In one of his first pieces, *Sagrado Corazón Activo* (*Active Sacred Heart*), 1991, for example, the artist inserted the pumping heart of a cow at the center of an acrylic cross filled with a saline solution of the kind used in heart transplant operations. The heart was connected to a small device that imparted a cardiac rhythm to the displayed organ, the whole becoming a modern-day icon in which the discourses of religion and medical technology interconnect. This was an appropriate juxtaposition in a country where public health is precarious and physical soundness a function of wealth (a problem not limited to Venezuela to judge from the numbers of poor people, many of them immigrants, who die from untreated diseases in cities like New York).

Hernández-Diez has also linked the transcendental body of religion to the post-human subject, which has been the focus of much contemporary art in recent years. For Hernández-Diez, the post-human is not only the outcome of the rationalized behavior and controlled communication that characterizes the inhabitants of the "society of the spectacle." Instead, a condition of post-humanity is linked to social and political processes that push individuals to the urban peripheries while becoming the detritus and human waste that exists outside social normalcy. A recent work entitled *Buscando vicio y sin dinero* (*Searching for Vice with No Money*), 2000, associates the absent body with the subculture of drugs to be found in cities such as Caracas, New York, and Barcelona, where the artist currently lives. Huge spoons made of bright yellow and gray acrylic have been bent double, which is the shape these everyday objects acquire when used by heroin addicts. Given this information, the work functions quite unambiguously in conceptual terms. But a closer look at the series of spoons suggests that these deformed and disfigured objects do not settle for one meaning and ponder the arbitrary limits between art and everyday objects, social commentary and creative process, found or ready-made work and invented form, normality and otherness, mass production and craft. Indeed, the spoons, as they were shown at the Centro Galego de Arte Contemporánea in Santiago de Compostela, were scattered throughout the space with another series of spoons (with the same colors, materials, and dimensions) which were called *Untitled*. Some of the handles were twisted into spirals; in others, the oval body of the spoon was bent towards the handle and reclined against a corner. In yet another group (entitled *Super Breakfast*), the shape of the spoons was left intact while they hung from the wall alluding to more conventional exhibition procedures and the legacy of the ready-made.

The toy quality of these sculpture/objects, their gigantic size, distorted shapes and unexpected configurations, "played" on the absurdity and violence of definition and identity, and bespoke post-humanity, not as the condition of a zeitgeist, but as the inevitable residue of modern life. This is also indicated by the process of production favored by Hernández-Diez in the construction of his works. While the objects that the artist appropriates are commonly mass-produced, he uses industrial materials and techniques to alter their original shape and scale. Pictures of the artist laboring with workers in the factory where the spoons and other pieces are made attest to the degree of manipulation required to shape these otherwise mass-produced objects. At stake is an ample and eclectic understanding of artistic production which undermines the dominance and authority of one model (the mechanical) in detriment of another (the hand-made) or vice-versa. The works are obviously industrially produced, or industrially deformed one might say, but the imperfection of the crafted object is recovered in this hybrid model of flawed machines and humans. Allegedly absent from the process of industrial and mass production, the body returns here as an unconscious, a memory, an absence whose residual presence we might sense in the everyday objects we manipulate.

The strategy of gigantism on which the spoons are predicated was developed in at least three other series of works. Two of these were done in 1996 and shown at Sandra Gering Gallery in New York in October of that year. *Que te rinda el día I y II* (*Have a Productive Day I and II*), 1995, consists of a wooden table and chair both of which bear the marks of a huge human bite. But the trace of this enormous absent jaw was the result of a specific attack perpetrated in a factory in Caracas where the artist produces most of his works. Photographs of that event show a strange machine in the form of a jaw whose huge teeth have been welded together. The bizarre effect of the bite marks on the wood pieces in the gallery correspond to the monstrous quality of this archaic object whose fabrication followed standard sculptural procedures. At stake, partly, was a reintroduction of the repressed body of abstract modernity. This was implied by two monochromatic diptychs that bore, in a symmetrical, noncompositional fashion, the indexical surplus of the big bite.

This reflection on sculptural/pictorial procedures, cannibalism, disfigurement, and industrial production was posed again in a series of C-prints produced the following year. These employed the genre of photographic portraiture to elaborate strategies of destruction that opposed the idealized procedures common to the genre. In the photographs, one can see bitten and disfigured plastic toys of the kind children find inside piñatas as trophies for their merciless attacks on these cardboard dolls hanging from a tree or a beam. The participants are children, blindfolded, guided, and exhorted by their parents to hit the piñata hard. This "cute" event of little people holding large poles, their faces semi-transfigured or confused in their search for the target, is a foretaste of adult life: "If you want something, you hit it, you kill it, and then you eat it." Which is exactly what kids do after the piñata's contents fall in their laps. Is this human nature before social restraints are programmed in? Hernández-Diez has no answer to give: instead, he radically alters the scale of the image by photographing the small bitten toys with a magnifying lens. The elegance of the C-prints contrasts the formless matter of these minor, mass-produced objects, where a reversal of shape is produced by a reversal of sculptural modeling— instead of hands as tools, the mouth; instead of additive techniques, reductive techniques.

Gigantism was taken up again in a series of pieces from 1998 and 1999, which imitate the shape of acrylic fingernails. Each nail measures approximately 90 cm x 50 cm and is shown individually or in groups, set up on a table or in the shape of a daisy. In *Margarita*

MONICA AMOR

(Daisy), 1999, a circle of nails set up around a center—nails, petals and woman—become an obvious symbol of femininity. Seeing these sleek objects, simply manicured nails without fingers, blown-up out of proportion, one wonders if there is a relation between Hernández-Diez's sculptural strategies and those feminist discourses which question the notion of "man as measure of all things." But if in these more recent works, a certain notion of bodily residue (nails are, finally, only dead cells) is thematized via an attack on sculptural strategies and their problematic relationship to industrial production and the objects of mass consumption, earlier works by Hernández-Diez took up images of the body (not its absence or lack) as a point of departure. Indeed, the violence implicit and uncannily felt in the distorted spoons, the bitten objects, and the disembodied nails, all blown up in the face of the viewer, has its antecedents in earlier works which addressed the complex relationship between urban detritus and bodily fragmentation through assemblage techniques and video.

The temporal relay of video was introduced in two seminal pieces from the early nineties. These works made use of mass media and technology to reflect on their capacity to distance one from reality, particularly the political reality of everyday life. In both pieces: In God We Trust, 1991, and Vas p'al cielo y vas llorando (You Go to Heaven and You Go Crying), 1992, Hernández-Diez conflates the iconic presence of mechanically reproduced images with the disembodied virtuality of video images (and religion as invoked in the titles) to deliver visual structures of great complexity. In In God We Trust, a large pyramid projects suppressed footage from the riots that erupted on February 27, 1989, in response to neo-liberal economic measures imposed by the Venezuelan government ten days before. The images of abandoned and convulsive bodies projected on the wall contrast with the image of a blinking eye on a 13" TV monitor embedded in the pyramid. The title of the work and the pyramid are direct references to the inscription one finds on U.S. dollar bills and by extension to the imperialistic dynamics that have dominated the economic and social life of Venezuela. But the work also delivers the crucial events of 1989, which radically changed the political and civil life of the country, as both mirage and somatic impulse, since the flowing images of violence are inextricably linked to this witnessing eye which has nowhere to turn.

This layering between referent and meaning, the distance between facts and memory, was thematized further in the video piece, Vas p'al cielo y vas llorando. Here, the spectral images of children levitating with their feet perpendicular to the visual horizon conflate the discarded bodies of social excess (the thousands of children killed in the streets of South America) with the sacred and culturally engrained idea that innocent children go to heaven. Georges Bataille summed up the operation of conflation of opposites with the notion of the "[heterogeneous] foreign body." The latter allows for an identity between excrement and the sacred, both untouchable and foreign, for which the image of "a half-decomposed cadaver fleeing through the night in a luminous shroud can be seen as characteristic."[3] In Bataille's image of the heterogeneous foreign body, there is a critique of the moral farce based on human exploitation as well as a reflection on the figure of waste and excrement that the homogeneous intellectual system of philosophical thought produces. Heterology in Bataille's work is thus determined to recover the excremental forces of human thought, that which cannot enter meaning or reality because it is outside of objectification or rational comprehension. Accordingly,

4 Ibid., 99.

3 Georges Bataille, "The Use Value of D.A.F. De Sade," in Voices of Excess, trans. Allan Stoekl (Minneapolis: University of Minnesota Press, 1985), 94.

"a burst of laughter is the only imaginable and definitely terminal result—and not the means—of philosophical speculation."[4] This is part of the reaction that the gigantic and deformed objects of Hernández-Diez produce with their attack on the standard body and the prototype of homogeneous mass production: a laughter in the face of absurdity and a constant deferral of meaning and truth.

The medium of video furnished the artist with the tools to create a visual structure in which both sign and signified could be suspended through fragmentation and a non-narrative temporality in which a monotonous activity takes place. Consider, for example, Indy, 1995, a video installation consisting of four wooden tables on which one can see four TV monitors, each crowned by a pair of skateboard wheels. Each monitor shows a video of a hand holding and pushing a pair of skateboard wheels down the street. The action is continuous, the background uniform, and the hand is visually severed from the body. Skating, an urban subculture in and of itself to which the artist refers frequently in his work, is generally perceived not so much as a real sport but as an eruption of time-wasting disturbance in the city streets and in spaces of institutional authority, such as the large promenades in front of monuments or government buildings. Here, the insubordinate character of waste is related to that which is outside systems of order, outside the daily activities of labor and production, outside regulated leisure and engineered desire.

Another video piece from 1995 entitled X-I is also predicated on bodily fragmentation and the presentation of an uninterrupted action. It consists of a shelf of wood upon which one encounters a small TV monitor being expelled from a large brown paper bag. The monitor shows a video of the head of a penis from which a stream of yellow urine is projected parallel to our visual horizon, defying all rules of gravity. One can recognize in these strategies of positional reversal the attacks on form and shape typical of works from the late nineties. But, if in these later works the residual body of modernity was implicit only through its absence, here only a part of the whole, performing wasteful tasks, is present.

If one can recognize a systematic operation in the work of Hernández-Diez, it is a certain estrangement that delivers the body as monstrous/gigantic, spectral/absent, fragmented/wasteful— in short, abject. La Hermandad (The Brotherhood), a large installation produced in 1994, summarizes the heterogeneous ensemble of strategies, materials, techniques, and ideas that run through the artist's work. Hanging from a metal rack, a series of skateboards made of fried pork skin (to which plastic wheels have been attached) emulate a decayed assembly line. On a large wooden table, three TV monitors show: 1) the frying of the skateboards, 2) the skateboards rolling down a street, 3) the skateboards being eaten by dogs. Remains of a skateboard lie next to this last TV monitor, although proof of their precarious nature is really not necessary. The repulsive vision of these deformed, chewable masses with wheels are enough to indicate their uselessness for the already useless activity of skateboarding. To learn that fried pork skin is a favorite snack among the disenfranchised classes in Venezuela and other countries in Latin America only adds to this conflation of structures of waste. And it is here, in Hernández-Diez's most visceral installation, that the body comes back with a vengeance, not as absence, not as specter; but as matter, a matter of fact.

THERE COMES A MOMENT when looking at the untitled 1997 work by José Antonio Hernández-Diez [formerly titled *Arroz con Mango (Rice with Mango)*] when one realizes it's about xenophobia. At first inspection, it is casually unassuming: a long wide metal table, from which hang a number of metal bats. The piece is obviously interactive. The viewer is invited to strike the table with one of the bats. Doing so produces a sudden barrage of sounds sampled from local radio, emerging from a number of speakers hidden under the table. Whether music, sports, a commercial, or a fragment from a call-in show, the sounds are typical examples of radio belonging to a cultural minority that is at once local and foreign. Not only does the immediate source of each sound change depending on where the table is tapped, but it is possible to have one or two sources alone or all of them blaring at once, since with a follow-up tap in roughly the same spot, the noise stops.

This work appears to offer the simplest form of interactivity, yet it also has a malevolent side. First, it is designed as a form of competitive sport, testing one's speed and precision in activating and deactivating various sounds. (Though the table is covered with dents, it continues to work even after a great deal of abuse.) Given the fragmented nature of radio and television in most urban areas, where a large portion of the sounds one hears originate from cultures different from one's own, the work seems merely to offer a way to change stations until you find the one you want. In Hernández-Diez's re-imagined world, however, all the sounds are from an "other's" culture. With this piece, the decision not to listen, normally carried out by turning a knob or pushing a button, is made through the violent act of hitting the source of the unwanted sound with a bat.

This work was created for an international exhibition called *InSite*, a biennial event that takes place simultaneously in the border cities of San Diego (U.S.) and Tijuana (Mexico). Participating artists are encouraged to make works that deal with border issues, one of the most important of which is the existence of political inequality. It is generally agreed that the fabled prosperity of southern California depends upon a constant flow of labor from Mexico; despite their numbers, these workers remain all but invisible to middle-and upper-class Californians. As a result of the situation in California, Hispanic culture is associated throughout the U.S. with an economic underclass, making for a continuous, though subtle, dehumanization that permeates daily life.

Similarly, very few non-Spanish speakers pay much attention to Spanish music and television, skipping past it without a thought. Human nature being what it is, it is conceivable that a certain number of people might react much more violently to Spanish radio, for example. Hence, Hernández-Diez's piece can be read as an open invitation to express, in the bluntest physical terms, the inherent hostility that one possesses towards the culture of the "other." Offering a sophisticated art audience an outlet by which a dyed-in-the-wool racist might enjoy working out pent-up aggression against Mexicans (or Puerto Ricans, or the homeless, or Arabs, depending on where his piece is installed), Hernández-Diez does not so much satirize xenophobia as play to its lowest common denominator: the urge to bash in someone's head with a baseball bat. Here the artist is not editorializing, that is, arguing that racism can be countered by scorn or despair. Instead, he offers a crude

DAN CAMERON

mechanism for luring hatred into the open and exposing it to the light of day.

Games are an abundant source of metaphor for Hernández-Diez. From children's singsong variations of follow-the-leader to organized adult sports, he is fascinated by the ritual element of games, as well as by their capacity for instantly forming self-identified groups with specific mythologies and patterns of behavior. To a striking degree, Hernández-Diez is intrigued by how sports and games restore to human beings physical competition and predatory behavior that no longer assure survival in postindustrial society. Taking failure rather than success as his point of reference, Hernández-Diez likes to put viewers into what is commonly referred to as a lose-lose situation. In the untitled work described above, the absence of a precise standard for winning or losing means that each interaction with the table will heighten anxiety, instead of relieving it with a clear-cut outcome. In Hernández-Diez's best-known and most widely written-about work, La Hermandad (The Brotherhood), 1994, skateboards made from meat, hanging on drying racks, have apparently reached the end of short but active lives, which are replayed endlessly in three accompanying videos. His most recent photographic works, in which names of great thinkers (Hume, Marx, Kant, Jung) are spelled out using the logotypes of stacked sneakers, carry a subtext concerning the marketing of a contemporary sports-oriented "lifestyle" to the entire socioeconomic spectrum, especially to those for whom these venerated names, and the lofty concepts they embody, are largely meaningless. Just as the sneaker-owners' aspirations have been compromised by the overall poor quality of the shoes themselves, so too are the desires of any passing economist harboring a desire to educate the masses about the economic system in which they are ensnared.

One of Hernández-Diez's most important early works, El Gran Patriarca (The Grand Patriarch), 1993, is based entirely on expectations frustrated during an act of sport: a billiard table at which a mecha-nized arm—holding a cue—repeatedly attempts a shot that never connects with the ball. The shot, which would clinch the game, is perfectly lined up; the arm is retracted with confidence, but at the crucial moment, no contact occurs. Both the anticlimax of the shot that never happens and the impotence implied in the work's mocking title suggest fear of being cut off from one's source of power, of being unable to follow through what one has started. At one level El Gran Patriarca is dealing with the politics of Hernández-Diez's native Venezuela, a country whose recent history has differed greatly from its neighbors due to its immense oil reserves, which give it a coveted seat (and occasional chairmanship) at OPEC. Despite the country's staggering oil wealth, the vast majority of Venezuelans have an extremely low standard of living. This is due primarily to corrupt political, military, and business leaders, who have skimmed off much of the country's oil revenue and produced a tiny, super-rich elite while the middle class has steadily shrunk for decades.[1]

Venezuela is also the product of a machismo-based culture embodied by the national hero, Simon Bolivar, first in a line of military leaders leading up to the current President, Hugo Chavez, a former army colonel who in the early 1990s led an unsuccessful coup attempt against a civilian government before winning in an election. In fact, the cult of the strong man has not provided Venezuela with

either stability or prosperity; indeed, it may well be responsible for systematically depriving the Venezuelans of their share of the national patrimony. In light of this, El Gran Patriarca is an allegory about how the quest for power undercuts the ability to know or to do what is best. Its grim determination to continue repeating the ill-fated shot after countless failures reveals a macho obsession with the vanity of the endlessly futile gesture. Grounded neither in politics or gamesmanship, another earlier work by Hernández-Diez, San Guinefort (Saint Guinefort), 1991, involves the viewer in a similar kind of dialogue about futility. Presented as a standing transparent Plexiglas case to which two sets of latex gloves have been attached, the work invites the viewer to put his/her hands into the gloves and touch the occupant of the case, a dead, artificially preserved German shepherd. Based on an ancient Christian myth about a dog believed to have saved the lives of an entire village, San Guinefort conflates the reliquary, a container where the bodily remains and artifacts of saints are stored and worshipped, with a specimen tank lifted from the world of medical technology. This somewhat morbid preoccupation with commingling the sacred and the corporeal represented a phase during which Hernández-Diez explored a link between the visual systems of organized religion, particularly Catholicism, and high technology. Recalling that the proof of touch is one scripturally sanctioned remedy for religious doubt (the story of the apostle Thomas on Easter Sunday, asking to touch Jesus' wounds, exemplifies this conundrum), San Guinefort exposes a contradiction between two powerful systems of faith: we are permitted to touch the "saint," but are denied the reassurance that the relic is indeed sacred. A fundamental link between El Gran Patriarca and San Guinefort can be found in the two works' shared embrace of corporeal sensation as the ultimate arbiter of the real: the grimly physical fact of a robot hand shooting pool and the touch of an animal cadaver to the fingertips of a gloved hand.

Another compelling, yet disturbing, characteristic of Hernández-Diez's work is his embrace of a kind of material poverty. Eschewing the look and feel of expensive materials and processes, he searches instead for a vocabulary of commonplace objects and images which he proceeds to treat in exaggerated form. These include the oversized bent plastic spoons that constitute a series of sculptures from 1999, the images of stacked running shoes mentioned above, and the pressboard furniture from which a pair of giant jaws appears to have attempted to take a bite. These items have been drawn from a world of objects in which the quality of a thing's manufacture, and its place within the evolution of a form's design and/or function, signifies less than its place within the artist's more idiosyncratic system of codified meanings. Hernández-Diez's identification with the bare standard, or the generic example, over the refined recalls other artists who have explored a similar terrain. Specifically, Arte Povera in Italy in the 1970s raised everyday experience to a level of transcendental value, so that a quality of loss, associated with cultural values left behind, inevitably attached itself to the objects so deployed. This is quite far from Hernández-Diez's intention in singling out the unexceptional for special attention. Likewise, certain older South American conceptually based artists also explored the universe of material deprivation in their work, but their approach had little to do with Hernández-Diez's. The Argentine artist Victor Grippo, who in the 1970s made

1 Several of Hernández-Diez's earlier works, such as In God We Trust, 1991, explore the disparity of wealth in his home country with a special intensity, as if drawn to the social spectacle created when the poor rise up and demand to be noticed.

the potato famous as a quasi-political symbol of the invisibility of the individual, may be the most comparable, but his attachment to the symbols of an agrarian society seems foreign to Hernández-Diez's aims.

Most striking about Hernández-Diez's embrace of material poverty in his work is his awareness of the disappearance of design or fabrication standards as a principal feature of the new urban wasteland. In the furniture-based work *Ceibó*, 1999, the rear-projection of a video onto the front of a storage cabinet provides a retrospective view of a moment in the life of the same cabinet when one of its owners packed up all his things and moved away. At first it seems quite different from his other works, but *Ceibó* maintains Hernández-Diez's plainness of presentation and sense of ritual. The bland repetitiveness in *Ceibó* centers on the loose irony surrounding an object of furniture used for storage, which itself requires dismantling and storage in order to be moved from one place to another. We see objects being removed from the inside of the cabinet but have no way of knowing what, if anything, remains inside it. There is no lingering air of nostalgia surrounding the piece, only a mundane sense of transitory movement, as if the next effort to unite cabinet and contents promises to be no more lasting than this one. In one respect, *Ceibó* is about the relationships we have with objects, but it is also about the escape of the self through relationships. The figure unpacking and re-packing the cabinet's contents is the artist, seen from a slightly distorted angle, as if in a reflection, and his attention seems to be less on the task before him than on circumstances taking place just outside our range of vision. The ordinary objects moving from inside to outside may not be able to reveal much about what has happened, or why, but we are reminded that, under the circumstances, they are all we have.

In its positioning of the mundane as a container for a complex range of affective and metaphorical principles, *Ceibó* opens up one of the central paradoxes in Hernández-Diez's art: the tension between the found and the fabricated. None of his works are precisely one or the other; rather, they manage to be both at the same time, with scale often providing the artificial element. In his most recent works, Hernández-Diez reminds us that industrial processes play a generally hidden role in the production of the objects populating our daily lives. By bringing them to the forefront, he has us experience them as manipulative, even coercive. The fingernails in *Soledad Miranda*, 1998, for example, are disturbingly gigantic; otherwise they are made from the same materials, using the same techniques, as artificial fingernails around the world. This is precisely what makes our contemplation of them both comical and threatening, as if the super-race that would make use of such gargantuan accoutrements is only a step away from making an appearance and claiming rightful dominance over us mere humans.

A similar paradox is at work in Hernández-Diez's 1999 untitled series of plastic sculptures replicating, at ten times their normal scale, the plastic caps that hold batteries in place in many toys, gadgets, and remote-control devices. Like the fingernails in *Soledad Miranda*, the battery caps have been laid out for our inspection, organized into small piles and other more or less arbitrary groupings that completely contradict their apparent utility as things. It is impossible to contemplate these emblematic

groupings without fantasizing how they got that way (one can imagine dozens of giant batteries spilling out of their holders), and it is difficult not to see them as blank repositories of the industrial processes responsible for their existence. Removed from the context of actual use, yet easily identifiable from their distinctive shapes and markings, the battery caps become stranded between the act of discovery and the idea of functionality. Unable to use them for what they were intended, we can only mentally pile them into little heaps, aware not only that they belong to a world with rules much different from our own, but also that we are too small to do anything about it.

A guiding principle of Hernández-Diez's work is the discomfort of the human species caught between its animal state and something more exalted. It is the paradox underlying what it means to be human that provides the universal bond in his art, connecting works that seem separately motivated by politics, morality, or group behavior. For Hernández-Diez, there is a fundamental contradiction between the revelatory experience intrinsic to the works of art and our aspiration to greater things in our lives. Marking and reinforcing the contradiction between our desire to act like a highly evolved species and our inescapable tendency to behave like animals, Hernández-Diez reflects a humanistic resonance within his art without simplifying the moral quagmires created by contemporary society. If Hernández-Diez's fascination with death, with abuse of power, with meat, and with gigantism seems to express a diminishing of the human subject as traditionally represented though art, it is in great part because the mass media have accustomed us to seeing ourselves either as brute subjects or as manipulators of vast technological grids that separate us from corporeal reality. In fact, being fully evolved as a person means embracing aspects of ourselves that are frightening or ridiculous, and integrating them into the image we have of ourselves as individuals and as a species. To a much greater degree than most contemporary artists, Hernández-Diez aspires to yank us out of a comfortable, but limited, self-image and remind us that we are both descended from primordial ooze and expected to work miracles. That done, he drops us, surprised and a bit chastened, back inside our newly unfamiliar skins.

CHRONICLE OF AN OUEVRE

JESUS FUENMAYOR

TRANSLATED BY JULIETA GONZALEZ

> Paradoxically one of missed encounters, ours is a continent united in and by its diversity.
> Miguel Miguel [1]

I. José Antonio Hernández-Diez belongs to a generation of Latin American artists who have become internationally known in an art world increasingly dominated by a model of global development and cultural plurality, in contrast to the post-war dichotomies (center-periphery relationships and the East-West block powers) that prevailed until not too long ago, with their respective models of social development.

Much like other artists who have emerged during the last decade in South America, such as Ernesto Neto, Doris Salcedo, Francis Alÿs, Kcho, and Fabián Marcaccio, José Antonio Hernández-Diez's concerns revolve around tensions between the artistic and the political. There is a clear departure here from the previous generation of artists, whose work did not express these tensions but was perceived on one or the other extreme (political art and art for art's sake were two basic options).

This is the result of a very complex process, of advancements and regressions. A generation of artists, among whom we can count some of those who contributed to the legitimization of contemporary art practice in Latin America, was briefly inscribed in what nowadays we call conceptualism. The work of Hélio Oiticica, Luis Camnitzer, Cildo Meireles, and David Lamelas, among others, belongs to a moment, at the end of the 60s, in which the dissemination and diffusion of contemporary art confronted the reductionism typical of a linear historical vision. The failure of these attempts of rupture left many of these artists, once again, debating the clichés associated with being Latin American. [2]

This first moment—in which the avant-garde became inscribed within a system desiring to set aside existing geopolitical restrictions—anticipated the conditions in which the works of artists belonging to Hernández-Diez's generation have been received. This process, with its heavy political burden, has, paradoxically, paved the way for a critical approach to the work of the artists in terms of their individual input, without necessitating that this kind of approach presupposes a negation of those contrasts that need to be acknowledged in order to understand the contribution of these works to the complexity of the art of our times.

This reading of the work of Hernández-Diez seeks to build on that platform of complexity achieved by previous generations, in the same way that the artist himself has built on it through a career characterized by its ability to take advantage of the elasticity legitimated by contemporary idioms. The effort becomes one of addressing the work of an artist who, in his individuality and via the logic that configures his investigation from within, has been able to integrate his work within the vastness of present-day art.

II. In the first stage of his work (1988-1991), Hernández-Diez positioned himself as one of the few Venezuelan artists to make video central to his practice and give it as much importance as any other medium. [3]

By the time Hernández-Diez began to produce significant work, a series of historical changes with enormous bearing on the work of artists was taking place around the world. In 1989, Venezuela

1 Miguel Miguel, *Redefinir la Vanguardia, Sin Fronteras /Arte Latinoamericano Actual* (Caracas: Museo Alejandro Otero, 1997), 13. (exhibition catalogue)

2 I refer specifically to that moment in which a series of circumstances led to the idea that the rupture with historicism should take place via declaring the death of the avant-garde. As a result, the postmodern idea of "the old considered as new" ended up being retrieved by the canon it was originally supposed to attack.

3 Luis Angel Duque, the curator who organized the first exhibition of Venezuelan video art, mentioned Hernández-Diez along with five other artists, stating that with their work "video art in Venezuela finally is considered at the level of sculpture, with the new medium acting as a conceptual and structural part of sculpture." He refers to a period in the 1980s in which "a new medium was being incorporated into national art." Galería de Arte Nacional, *La Década Prodigiosa, Los 80 / Panorama de las Artes Visuales en Venezuela* (Caracas: Galería de Arte Nacional, 1990), 42-43. (exhibition catalogue)

experienced a revival of interest in the artists of the 1970s.4 Aside from Meyer Vaisman, who would exert a very special influence upon emerging artists, these included Sammy Cucher, José Gabriel Fernández, Oscar León Jiménez, Alfredo Ramírez and Hernández-Diez himself, who gave new currency to the production of artists such as Sigfredo Chacón, Héctor Fuenmayor, Víctor Lucena, Roberto Obregón, Claudio Perna, Antonieta Sosa, and Alfred Wenemoser. Viewing the contributions of these artists not as a stylistic legacy but in terms of the opening of procedures their art implied, Hernández-Diez's generation broke with the modular structure of the local historical narrative. These artists situated themselves in an intermediate space, opening up the possibility of producing their work without tying themselves to the two local currents—on the one hand, a sort of nationalist crusade, and on the other, the cosmopolitan hunger represented, in Venezuela, by artists who from the 1950s on imported from Europe the canons of constructivism. In that moment, in which the return of painting prevailed, the first works of Hernández-Diez were read in light of the need to break with the historical model, a rupture that hegemonic theory was demanding at the time. This internationalization of local discourse in terms of a critical approach to art could only define the work of Hernández-Diez and of other artists of his generation as part of a tendency employing new mediums; as such, it lumped them into the category of the avant-garde.

The early works of Hernández-Diez addressed aspects traditionally characteristic of video—its heavy narrative charge, the possibilities of hybridization, the specular-narcissistic, and the juxtaposition of political and artistic contents. However, and parting from an awareness on behalf of the artist of the foundation laid out by the preceding avant-gardes, we can perceive in these works a need to go beyond medium-specific concerns. This has been a constant in his work, which Kurt Hollander has identified in reference to two later works by the artist, *Tres XXX*, 1993 and *El Gran Patriarca* (*The Grand Patriarch*), 1993. Despite the difficulty of connecting these works because of the formal differences between them, Hollander sees them as an "exercise in repetition and frustration"; in *Tres XXX* this exercise is made evident in the image of a child attempting to score the basket in a makeshift basketball court; in *El Gran Patriarca* a robot designed by the artist to play pool is always doomed to fail.5 This is similar to what happens in the first works of the artist in which despite the constant recourse to video what interests the artist is not a definition of the limits between mediums.

A trait common to these early works, demonstrating Hernández-Diez's interest in going beyond video, is the use of claustrophobia as a metaphor for one of the aspects most dear to the post-war avant-gardes: the participation of the spectator being intrinsic to video art. In *Annabel Lee*, 1988, for example, the artist makes a model of the tomb of the character from the Edgar Allan Poe poem of the same name. On top of a glass box filled with earth is a small diorama representing a tombstone at a burial site. Below, a small monitor buried under the earth allows us to see, through an opening roughly in the proportions of a coffin, a video in which the agony of Annabel Lee—who was buried alive—is reenacted. The work makes an obvious reference to television as a crypt that encloses inanimate and lifeless beings.

4 After a period in which the return to painting dominated the local scene, several figures began stimulating a different perception of art, namely, *Estilo* magazine, curator Miguel Miguel at the Sala RG, the collectors Ignacio and Valentina Oberto, Galería Sotavento, and the Galería de Arte Nacional, which encouraged the return of artists who had not produced or exhibited work in a long time.

5 Kurt Hollander, "The Caracas Connection", *Art in America*, no. 7 (July 1994): 83.

6 Dan Cameron, *Cocido y Crudo* (Madrid: Museo Nacional Centro de Arte Reina Sofia, 1994), 54. (exhibition catalogue)

Houdini, 1989, is a self-portrait of Hernández-Diez as the famous escape artist, in his last and fatal performance. Here, Hernández-Diez accentuates the sensation of enclosure and frustration in the space of art, the impossibility of breaching its limit, and the anxiety the spectator experiences in his/her incapability to change the outcome of the narrative. In *Los sueños no duran más de cinco minutos* (*Dreams Don't Last More Than Five Minutes*), 1988, its title alluding to Andy Warhol's "fifteen minutes of fame" (the great parody of participation), the artist resorts to the loop, so typical of video-montage, in order to exaggerate the circularity of the oneiric imagination, interpreting the video as a dream capsule where the work isolates itself from the spectator. In his video installation titled *In God We Trust*, 1991, the extremes of a historically decisive moment are portrayed. A metal structure built to look like the Masonic pyramid that appears on one-dollar bills contains two videos: one depicts images of corporate buildings traversed by eyes; the other shows the Caracas street riots of 1989 that changed the course of history in Venezuela. Operating as a social mirror of sorts, this work is considered crucial in the sense that it represents the symbolic end of the divorce between art and the local context in Venezuela, which could be said to have been one of the banners of kinetic art which represented for many years the main artistic idiom in the country. In terms of participation, the bi-frontality of the videos strips bare the power of the gaze.

III. A second phase is composed, for the most part, of works presented in Hernández-Diez's first solo show, *San Guinefort y otras devociones* (*Saint Guinefort and Other Devotions*), organized by curator Luis Angel Duque in 1991 in Caracas at the Sala RG, an alternative space run at the time by Miguel Miguel.

The first evidence of the internationalization of Hernández-Diez's work was to be found in this exhibition, in which the artist made clear his appreciation of the problematic convergence between modern technological development and the complex cultural processes that resist it. Dan Cameron, who, along with Gerardo Mosquera, took an international curatorial interest in the work of Hernández-Diez, observed how "by prodding our faith in the miracles that the last hundred years have achieved, Hernández-Diez tries to point out the invariable rift which occurs when that belief system tries to mesh with the even older tradition of Catholic iconography, as well as draw our attention to the failure of our society to offer even the most basic services to some its inhabitants."6

The 1991 exhibition consisted of six pieces from the series that the artist titled *Nueva Iconografía Cristiana* (*New Christian Iconography*). One of these was *San Guinefort* (*Saint Guinefort*), 1991, a desiccated and embalmed mongrel dog, locked inside a container that recalls scientific laboratory incubating devices. *San Guinefort* alludes to the forbidden cult of the holy dog as a protector of children. This work pushed the syncretism between technology and religiosity to extremes never before explored by other artists. It allowed Hernández-Diez to take on one of the dictums of Latin American artists in the '90s: the defeat of universality, the weakening of the centripetal forces of art, and the admission of other histories.

In *Lavarás tus pecados* (*You Shall Wash Your Sins*), 1991, Hernández-Diez turns an ironic eye on one revered icon of Christian devotion. The work consists of a washing machine embedded into a structure in the shape of a cross, with a purple shroud gyrating inside the machine. The sacred shroud, among the holiest of relics, is subjected to the aseptic discourse of modernity: if it is washed with modern technical efficiency, is its sacred quality lost? The question is also asked by *Sagrado Corazón Video* (*Video Sacred Heart*), 1991, another blasphemy wrapped in modern packaging: a Christian cross made of transparent acrylic, the interior of which houses a video showing an open-heart surgery. As María Elena Ramos states "the awareness, above all, of the fact that the more the mediums and fields of knowledge multiply and the more they encourage our research into them, the more partial is our knowledge about them. That certain consciousness of cognoscible modesty must face the desire for omnipotence that opens new scientific and technological accesses to knowledge." [7]

One must not forget that this series of works was produced in a time of Catholic upheaval, concurrent with the 500th anniversary of the first voyage of Columbus to America. It was a moment when different movements of Christian renovation (the Theology of Liberation in particular) were gaining a strong following in Latin America. One of the works by Hernández-Diez which evidences particularly close links to the discussions generated by these religious trends is *Fray de Las Casas* (*Saint de Las Casas*), 1991. In this work, a box designed like crates used to transport musical instruments and electronic sound equipment is transformed into a cross, its interior bearing the name of the famous friar who in the sixteenth century strove to make the Church recognize the indigenous peoples of the New World as human beings. [8]

IV. The next phase in the work of Hernández-Diez was perhaps the most amorphous, in terms of the plurality of forms and mediums that the artist employs.

Nevertheless, these pieces have a common denominator: they are "committed" and emphasize social concerns. *Minamata*, 1991, was made specially for an exhibition that addressed a satellite view of Venezuela. [9] The name *Minamata* is a perverse choice in the sense that the work consists of a giant pair of scissors, upon which is projected a video with submarine images of the aquatic fauna of the Orinoco River. From the mutilated bodies of the victims of the atomic bomb to the contamination by mercury of the world's main source of water (the Amazon basin), the only difference is the shift in place of the invisibility of both. The invisibility of the nuclear attack is located in the image of the mushroom cloud, which paradoxically makes us feel protected when we see it from afar. The invisibility of ecological destruction is situated only in the temporary, in the indifference produced by the knowledge that this is a preventive stage, and that this destruction belongs to the future and not to this generation.

In the same way that *Minamata* encourages the spectator to reflect on the relationship between the work and its title, and leads us to terrible conclusions, the rest of the works corresponding to this period are produced under that sign. *¿Por qué a mí?* (*Why me?*), 1991, is a self-portrait of the artist in a pose similar to the figure in

7 María Elena Ramos, *El Espíritu de los Tiempos* (Caracas: Galería Los Espacios Cálidos, Ateneo de Caracas, 1991). (exhibition catalogue)

8 Dussel identifies the first modern discussion in the debate between Bartolomé de las Casas and Ginés de Sepúlveda in which they discuss whether the aborigines are barbarians or humans. Taken from an interview with Carlos Basualdo and Octavio Zaya, *Acerca de la belleza futura: Enrique Dussel y la Filosofía de la Liberación* (Madrid: Eztética del Sueño, Museo Nacional Centro de Arte Reina Sofía, 1994), 27-28. (exhibition catalogue)

9 The original title of the exhibition was *Venezuela vista por satélite* (*Venezuela seen from the satellite*), though it was later changed to *Venezuela, Nuevas Cartografías y Cosmogonías* (*Venezuela, new cartographies, new cosmogonies*), Galería de Arte Nacional, Caracas, 1991.

10 Roberto Guevara, *I Bienal Barro de América* (Caracas: Museo de Arte Contemporáneo de Caracas Sofía Imber, 1992), 56. (exhibition catalogue)

Edvard Munch's *The Scream*. The image, printed on an aluminum sheet, hangs like a painting on a wall. Above it is a megaphone and next to it a baseball bat, baseball being the national sport in Venezuela. The work does not explicitly invite the spectator's participation, but the spectator is welcome to pick up the bat and strike the painting; in return, he/she will hear a scream. This work clearly presents a sadomasochistic vision of the relationship between art and spectator.

Another crucial work from this period is *La Caja* (*The Box*), 1991. Made in Bogota, specially commissioned for the 1992 exhibition *Ante América* (*Regarding America*), the work is precisely that, a cardboard box, displayed along with a video of street urchins known in Colombia as *gamines*. In the original version of the work, a transparent plastic screen, on which the video was projected, hung from the box. This arrangement, and the way in which the artist filmed the *gamines*, made it seem as if they were falling out of the box, as when one empties a garbage bag of its contents.

Some time before this, Hernández-Diez made a similar video installation called *Vas p'al cielo y vas llorando* (*You Go to Heaven and You Go Crying*), 1992. This work, also a video projection on a transparent plastic screen, takes children as the subjects of its narrative. The video was filmed in the Venezuelan Andes and the children seemed to levitate towards the sky because of the shift in vertical and horizontal axes of the projection. Roberto Guevara, curator of the Bienal Barro de América commented on this work: "from a mound of soil, such as those of humble graves, a vertical projection shows children in 'their best Sunday clothes' that emerge from the mound and slowly levitate. The title of the work, defines the situation with sarcasm: vas p'al cielo y vas llorando (you go to heaven and you go crying). This vernacular expression in Venezuela is employed to refer to unjustified protest. However, in this case the double meaning alludes to the innocence of children and the fact that their lives have been cut short prematurely." [10]

A recurring theme in the phases of Hernández-Diez's work is the relationship between childhood and violence. One work in particular may be understood as a mosaic of violence. *Vehículos perfectos* (*Perfect Vehicles*), 1993, was made in collaboration with art students in a painting class. Using photographs of school-age children, Hernández-Diez asked the students to make painted versions of these photographs on skateboards. The portraits represent children dressed up as *encapuchados*, university students but more likely "professional" agitators who often lead protests and clash with the police at the campus gates. In order not to be recognized, they wear t-shirts on their heads, hence the name *encapuchado*, which comes from *capucha*, or hood. Their routine usually includes throwing stones and Molotov cocktails. They are popularly viewed as the survivors of 1960s idealism turned into radical activists. However, their violence is only symbolic when compared to criminal violence that leaves around one hundred dead a week. *Vehículos perfectos* avoids the more brutal violence when it opts for a more terrifying alternative: to delegate this violence to future generations via the symbolic possibilities of art. Hernández-Diez's radical aesthetic departure from his previous works marks a definitive crossroads in his oeuvre. Even if these works allowed for his insertion within a new panorama of the arts in Latin America, his refusal to continue along these lines of research has had a

centrifugal effect. Taking this rupture as a starting point, we can no longer conceive of his work as one that underlines the relations with a particular historical moment but rather as one that concentrates on his personal language, within the set of concerns of someone who calls into question the sense of artistic practice beyond identity issues focusing on what it means to be Latin American or Venezuelan.

V. This rupture with, on the one hand, direct allusions to problems of identity, and, on the other, an interest in the revision of the mandates of the avant-gardes, seems to distance the work of Hernández Diez from external tensions, even while the previously analyzed works also bear the personal stamp of the artist. *La Hermandad* (*The Brotherhood*), 1994, made for the 1994 exhibition *Cocido y Crudo* (*Cooked and Raw*), employed some of the elements used by him earlier, such as skateboards, dogs, and video. Unlike previous works, the title of the work did not contain information that articulated it in any sense. The works that followed *La Hermandad* showed a resistance to being categorized as exotic or reduced to the status of derivative, and the issues addressed became more undecipherable by comparison to the clear historical compromise manifest in previous works. Hernández-Diez's interests, as the artist himself has confessed, turned to the realm of the private.[11] There is only one aspect of *La Hermandad* that can make us think about how the private experiences of the artists become evident in the work: the skateboards are made with pork rinds, a very popular "delicacy" in Venezuela, of Spanish origin. The work undoubtedly constitutes a vernacular commentary on the Spanish legacy when seen from Venezuela. Nevertheless, from the Spanish perspective, the use of pork rinds can also be seen as an allusion to an aspect of popular Spanish culinary culture. Using this strategy, Hernández-Diez deliberately mixes up the local with the international, thus scoffing at the local referents that are usually attributed to his work.

Progressively, the work of Hernández-Diez took a decisive turn toward hermeticism. For example, some of his video-assemblages made in 1995, which continued to focus on the teenage street world, resorted to close-up frames in order to eliminate all reference to context. Likewise, a 1995 video-sculpture titled *X-1* is a sort of schematic airplane consisting of a paper bag, corresponding to the plane's fuselage, attached to a TV monitor in which there is a video of the tip of a urinating penis. Since the image only frames the very tip of the penis, the reference is oblique. In another piece from the same series, *Indy*, 1995, the frame closes on the image of a hand that strokes the wheels of a skateboard.

The slow process of shedding direct commentaries which forced conditioned readings of the work became more accentuated. In a group of photographs of bitten dolls, from 1996, the artist resorted once again to the isolation of the subject via the camera frame. The toys were distorted—not only from the bites, but also because they are blown up to unnatural dimensions—and visually bear more resemblance to Francis Bacon's figures than to the actual reference implied by the real objects, small toys and trinkets dispensed from the typically Venezuelan and Latin American piñatas, which are often the cause of scuffles and fights in children's parties. This

specific, even private, reference becomes apparently irrelevant when the image of the object is blown up and in the process rendered abstract.

Perhaps the most mysterious aspect of the work of Hernández-Diez is his recent enlarging of objects as disparate as teeth, fingernails and toenails, lids and pieces of electronic equipment, and shoes. In 1996, he made a series of pieces consisting of furniture dented with enormous bite-marks. He then produced the series, *Soledad Miranda*, 1998, a set of giant artificial fingernails, an ambiguous homage to women. He later produced a series of magnified replicas of the lids that are used to cover the battery compartment of remote control devices; and in 2000, Hernández-Diez made a series of photographic works in which jogging shoes are piled one on top of the other in a vertical column, in such a way that the initials of their brand-names spell different names of European thinkers (Hume, Kant, Marx, Jung). Magnification is an extremely simple and commonplace operation. However, the scale sought by the artist does not have the same intent as in the case of other artists who have made this operation their distinctive trademark. In the case of the bitten pieces of furniture, the magnified object does not even appear, instead leaving only its mark. The nails are borderline cases; it is possible that we may recognize them, but once we have, there is little we can gather from that identification. The same happens with the lids of household appliances; their relation to the industrial process of fabrication, which projects the frustration of modern progress, is more important than the actual anecdotal identification of the object itself. The jogging shoes are equally intriguing. Here, the strategy of magnification is not simply one of excess; it seems to be ambiguously both at the service of legibility and a hindrance to it.

Contemporary culture is constantly forcing us to reinvent our ways of assimilating codes. Perhaps searching for the appropriate measure—one demanded by the work itself, the spectator, and the space—is a way of making visible the mutations of the codes that we find in the contemporary world. *Ceibó*, 1999, recuperates the theme of claustrophobia, already present in some of Hernández-Diez's early works, especially *Houdini*. For me, it is the best metaphor that the artist has made of his own work. By contrast with the desperation of the great magician trying to escape from his trap depicted in the early video, in *Ceibó* the artist shows himself as calm. As Carlota Alvarez Basso states, "it is a self-portrait of the artist in motion, while he looks in disorder at his personal memories. Once and again, in an infinite loop, José Antonio places and misplaces used and old objects that belong to his past. Only he knows what they mean. As if he were removing his own entrails, his personal and non-transferable memory, this image of the artist burying his past in a domestic piece of furniture is for me extremely moving."[12] This is a good definition of the work of Hernández-Diez; formally rigorous and extremely moving in its exposure to its own uncertainties.

11 In conversation with the artist, Buenos Aires, November 2000.

12 Carlota Alvarez Basso, *Le Soledad de José Antonio Hernández-Diez* (Caracas: Sala Mendoza, 1998), 7. (exhibition catalogue)

José Antonio Hernández-Diez

Caracas, Venezuela, 1964
Lives and work in Barcelona, Spain

Solo Exhibitions

2002 Sandra Gering Gallery, New York, NY
 Galeria Elba Benítez, Madrid, Spain
 Galeria Javier López, Madrid, Spain
2000 CGAC-Centro Galego de Arte Contemporánea,
 Santiago de Compostela, Spain
1999 Galería Antony Estrany de la Mota, Barcelona, Spain
 Galeria Camargo Vilaça, Sao Paulo, Brazil
1998 Sala Mendoza, Caracas, Venezuela
1997 Galería Elba Benítez, Madrid, Spain
1996 Sandra Gering Gallery, New York, NY
1995 Galeria Camargo Vilaça, Sao Paulo, Brazil
 Sandra Gering Gallery, New York, NY
1991 *San Guinefort y otras devociones*, Sala RG, Caracas,
 Venezuela

Group Exhibitions

2002 Opening exhibition, Palais de Tokio, Paris, France
 Ultra Baroque: Aspects of Post Latin American Art,
 Walker Art Center, Minneapolis, MN 2002;
 San Francisco Museum of Modern Art,
 San Francisco, CA, 2002;
 Modern Art Museum of Fort Worth, Fort Worth,
 TX, 2001;
 Museum of Contemporary Art, San Diego, CA, 2001
 INOVA, Institute of Visual Arts, University of Wisconsin
 Milwaukee, WI
 Arte all'Arte'01 – 6ª Edición, Arte Continua Associazione
 Culturale, San Gimignano, Italy
 Squatters, Oporto 2001, Museo Serralves, Oporto, 2001;
 Witte de With Contemporary Art Centre, Rotterdam,
 The Netherlands, 2001
 The Overexcited Body. Art and Sport in Contemporary Society,
 Ginebra
 Da Adversidade Vivemos, Musée d'Art Moderne de la
 Ville de Paris, Paris, France
 Megafino, Miami Beach, Convention Center, Miami, FL
 Carnegie International, Pittsburgh, PA
 Eztetyka del Sueño, MNCARS Palacio de Velázquez,
 Madrid, Spain
1999 *A vueltas con los sentidos*, Casa de América, Madrid, Spain
 The Garden of the Forking Paths,
 Nordjyllands Kunstmuseum, 1999;
 Edsvik Konst & Kultur, Sollentuna, Suecia, 1999;
 Helsinki City Art Museum, Helsinki, Finland, 1999;
 Kunstforeningen, Copenhagen, Denmark, 1998
 Pasajes de la Colección en Santa Fe y Granada, Colección de
 Arte Contemporáneo Fundación "La Caixa",
 Palacio de los Duques de Gandia, Granada, Spain
 Amnesia, Track 16 Gallery and Christopher Grimes Gallery,
 Santa Monica, CA
 Spectacular Optical, Thread Waxing Space, New York, NY

1997 *In Site San Diego 97*, San Diego, CA
 Así está la cosa, Sala de Exposiciones de Televisa, México,
 D.F. , México
 Colección La Caixa, La Caixa, Barcelona, Spain
 Arte Latinoamericano Actual, Museo Alejandro Otero,
 Caracas, Venezuela

1996 MOCA, Museum of Contemporary Arts, Miami, FL
 Universalis, XIII Biennal Internacional de Sao Paulo,
 Sâo Paulo, Brazil
 Camargo Vilaça Bis, Galeria Camargo Vilaça, Sâo Paulo,
 Brazil
 Sin Fronteras, Museo Alejandro Otero, Caracas, Venezuela
 Novas Aquisicoes-Coleçao Gilberto Chateaubriand, Museu de Arte
 Moderna, Rio de Janeiro, Brazil

1995 1st Kwangju International Biennale, Kwangju, Korea
 World Wide Video Festival, The Hague, The Netherlands

1994 *Cocido y Crudo*, Museo Nacional Centro de Arte Reina Sofía,
 Madrid, Spain
 Sandra Gering Gallery, New York, NY
 Annual Benefit Auction, The New Museum of Contemporary
 Art, New York, NY
 John Currin, Kate Buckhardt, José Antonio Hernández-Díez,
 Tony Ousler, Lorna Simpson, Sue Williams, Galleria Galliani,
 Génova, Italy
 Bienal de La Habana, Havana, Cuba

1993 *CCS 10/Arte Venezolano Actual*, Galería de Arte Nacional,
 Caracas, Venezuela
 The Final Frontier, New Museum, New York, NY
 News Adquisiciones 1991-1992, Galería de Arte Nacional,
 Caracas,Venezuela

1992 *Ante América,*
 Biblioteca Luis Angel Arango, Bogotá, Colombia, 1992
 Museo de Artes Visuales Alejandro Otero, Caracas,
 Venezuela, 1992
 Queens Museum, New York, NY, 1992
 Yerba Buena Center for the Arts, San Francisco,
 CA., 1992
 I Biennal de Barro de América, Museo de Arte Contemporáneo
 Sofía Imber, Caracas, Venezuela
 Sexta Edición Premio Eugenio Mendoza, Sala Mendoza,
 Caracas, Venezuela

1991 *Venezuela: News Cartografías y Cosmogomas*, Galería de Arte
 Nacional, Caracas, Venezuela
 III Biennal Nacional de Arte Guayana, Museo de Arte Moderno
 Jesús Soto, Ciudad Bolívar, Venezuela
 El Espíritu de los Tiempos, Galería Los Espacios Cálidos,
 Ateneo de Caracas, Caracas, Venezuela

1990 *Los 80: Panorama de las Artes Visuales en Venezuela,*
 Galería de Arte Nacional, Caracas, Venezuela
 III Biennal de Video Arte, Museo de Arte Moderno de Medellín,
 Colombia

1989 *I Reseña de Arte en Vídeo*, Sala RG, Caracas, Venezuela
 Vídeo Instalaciones, Galería Sotavento, Caracas, Venezuela

1988 *IX Festival Internacional de Super 8 y Vídeo*, Brussels, Belgium
 I Biennal Nacional de Artes Plásticas, Modalidades de Expresiones
 Libres y Fotografía, Galería de Arte Nacional y Galería
 Los Espacios Cálidos, Caracas, Venezuela

Bibliography

2001 Arte Continua-Associazione Culturale. *Arte All' Arte.*
San Gimignano/ Gli Ori, Siena, Italy, 2001.
(exhibition catalogue)
Musée D'Art Moderne de la Ville de Paris . *De L'Adversité,
nous vivons.* París, France, 2001. (exhibition catalogue)

2000 Armstrong, Elizabeth and Victor Zamudio-Taylor.
Ultra Baroque. Aspects of Post Latin American Art. San Diego,
CA: Museum of Contemporary Art, 2000, 45-50.
(exhibition catalogue)
Botella, Juan. "Vik Muniz y José Antonio Hernández-Díez:
doblez del sentido." *Galería Antiquaria* Año XVIII, Nº 185
(July/August 2000).
Centro Galego de Arte Contemporáneo,
José Antonio Hernández-Díez, A Coruña, Chile, 2000.
(exhibition catalogue)
de Diego, Estrella. "José Antonio Hernández-Díez."
InteresArte Nº 9 (2000).

1999 *VII Bienal de Artes Plásticas Ciudad de Pamplona.* Pamplona,
Spain, 1999, 38. (exhibition catalogue)
de Diego, Estrella. *A vueltas con los sentidos.* Madrid, Spain:
Casa de América, 1999. (exhibition catalogue)
Grynsztejn, Madeleine. *Carnegie International 1999/2000.*
Pittsburgh, PA: Carnegie Museum of Art, 1999, 40-41,
119. (exhibition catalogue)

1998 Fundación La Caixa. *Pasajes de la Colección en Santa Fe y
Granada.* Barcelona, Spain, 1998, 20.
(exhibition catalogue)
Gangitano, Lia. *Spectacular Optical.* New York, NY:
Thread Waxing Space and TRANS> arts.cultures.media,
1998. (exhibition catalogue)
Sala Mendoza. *José Antonio Hernández- Díez.* Caracas,
Venezuela, 1998. (exhibition catalogue)
Williams, Gilda, ed. *Cream: Contemporary Art in Culture.*
London, UK: Phaidon Press Ltd., 1998, 178-179.
Zaya, Octavio. *The Garden of Forking Paths.* Copenhagan,
Denmark: Kuntsforeningen, 1998. (exhibition catalogue)

1997 Balaguer, Menene Gras. "José Antonio Hernández-Díez."
Lapiz, no. 132 (May 1997): 76-77.
Navarro, Mariano. "El compromiso histórico de
Hernández-Díez." *ABC* (April 18, 1997): 35.
Auerbach, Ruth. "Escenarios colectivos: Noventa artistas
venezolanos testifican la producción artística de una
década." *Estilo* 8, no. 30 (April 1997): 73.

1996 Fuenmayor, Jesús. "Visita al taller de José Antonio
Hernández-Díez en Caracas." TRANS> *arts.cultures.media,*
no.2 (1996): 105-109.
_____. "Vacios de identidad. Anotaciones de la
contemporaneidad en Venezuela." *Atlantica Internacional,*
no. 15 (Winter 1996): 8-10.

1994 Auerbach, Ruth. *Quinta Biennal de La Habana.* Havana, Cuba:
Quinta Biennal de La Habana, 1994, 234.
Oramas, Luis Pérez. "La alegoría y la escala." *Art Nexus,*
no. 12 (April–June 1994): 80-84.

1993 Cameron, Dan. "Artificial Paradise." *Art & Auction*
(May 1993): 90-94.
Dannatt, Adrian. "The Final Frontier." *Flash Art,* no. 172
(October 1993): 79.
Fuenmayor, Jesús. "José Antonio Hernández-Díez."
Flash Art (1993): 304-305.
_____. "José Antonio Hernández-Díez." *Poliester,* no. 7
(Autumn 1993): 48-51.
Hess, Elizabeth. "Museum Bytes Dog, The Final Frontier."
The Village Voice (June 15, 1993)
Marks, Laura U. "The Final Frontier." *Artforum*
(December 1993): 83.
Ponce de León, Carolina. "Alternative Paths for the
Noble Savage." *Parkett* 38 (1993): 154-161.
Sichel, Berta. "News from Post-America." *Flash Art* (1993):
86-89.

1992 Vaisman, Mayer. "José Antonio Hernández-Díez."
Ante America (1992)
_____. "José Antonio Hernández-Díez." *Artforum*
(April 1992): 92.

1991 Duque, Luis Angel and Miguel Angel . *San Guinefort y otras
devociones.* Caracas, Venezuela: Sala RG, 1991.
(exhibition catalogue)
Herkenhoff , Paulo and Geri Smith. "Latin American Art/
The Global Outreach." *Art News* (October 1991): 88-93.

1990 Oramos, Luis Pérez. et al. *Los 80: Panorama de las Artes
Visuales en Venezuela.* Caracas, Venezuela: Galería de Arte
Nacional, 1990. (exhibition catalogue)

BIBLIOGRAPHY

San Guinefort (Saint Guinefort), 1991
acrylic, metal, rubber, animal cadaver
57 1/2 x 104 3/8 x 33 1/2 inches
Collection of Alfonso Pons, Caracas

Vas p'al cielo y vas llorando
 (You Go to Heaven and You Go Crying), 1992
video projection, screen, dirt
dimensions variable
Collection of Rosa and Carlos de la Cruz, Miami

El Gran Patriarca (The Grand Patriarch), 1993
pool table, mechanical arm
55 7/8 x 100 x 31 1/8 inches (pool table),
 9 7/8 x 59 x 9 7/8 inches (arm)
Courtesy of the artist, Barcelona

La Hermandad (The Brotherhood), 1994
3 video monitors, 3 tables, metal drying rack, troughs,
 fried pork skateboards
98 x 204 x 27 inches
Collection Contemporary Art Foundació "la Caixa", Barcelona

Que te rinda el día (Have a Productive Day), 1995
leaning panel, triptych, desk
installation of wood furniture (3 units), dimensions variable
Courtesy of Sandra Gering Gallery, New York

Sin título (Arroz con Mango) [Untitled (Rice with Mango)], 1997
aluminum-covered table, aluminum bats, audio track
47 1/4 x 96 x 35 1/2 inches
Courtesy of the artist

S & M I, 1998
acrylic, wood table, sand paper
35 1/2 x 31 1/2 x 141 3/4 inches
Collection of Ignacio and Valentina Oberto, Caracas

Ceibó, 1999
projected video, wood, glass, ceramic plates
35 1/2 x 82 5/8 x 23 5/8 inches
Collection of Museo Alejandro Otero, Caracas

Sin título (Untitled), 1999
13 acrylic (remote battery covers)
dimensions variable
Courtesy of Galeria Fortes-Vilaça, São Paulo

Sin título (Untitled), 2000
2 acrylic (bent spoons)
dimensions variable
Courtesy of the artist

Hume, 2000
C-print photograph
82 5/8 x 63 inches (framed)
Courtesy of the artist

Jung, 2000
C-print photograph
82 5/8 x 63 inches (framed)
Courtesy of the artist

Kant, 2000
C-print photograph
82 5/8 x 63 inches (framed)
Courtesy of the artist

Marx, 2000
C-print photograph
82 5/8 x 63 inches (framed)
Courtesy of the artist

EXHIBITION CHECKLIST

COLOPHON

PRINTING, PRE-PRESS & BINDERY
SYL Creaciones Graficas Y Publicitarias, S.A., Barcelona

PAPER
TEXT: Popset Maiz 90 gms
Hanno Art Silk 90 gms
COVER: Hanno Art Silk 300 gms

DESIGN & TYPOGRAPHY
Paul Carlos & Urshula Barbour | Pure+Applied, NY

TYPEFACES
Quadraat Sans: Fred Smeijers (1997)
Steile Futura: Paul Renner (1953–54)
Commerce Gothic: Jim Parkinson (1998)

2,000 copies of this catalogue were printed.

WORKS:

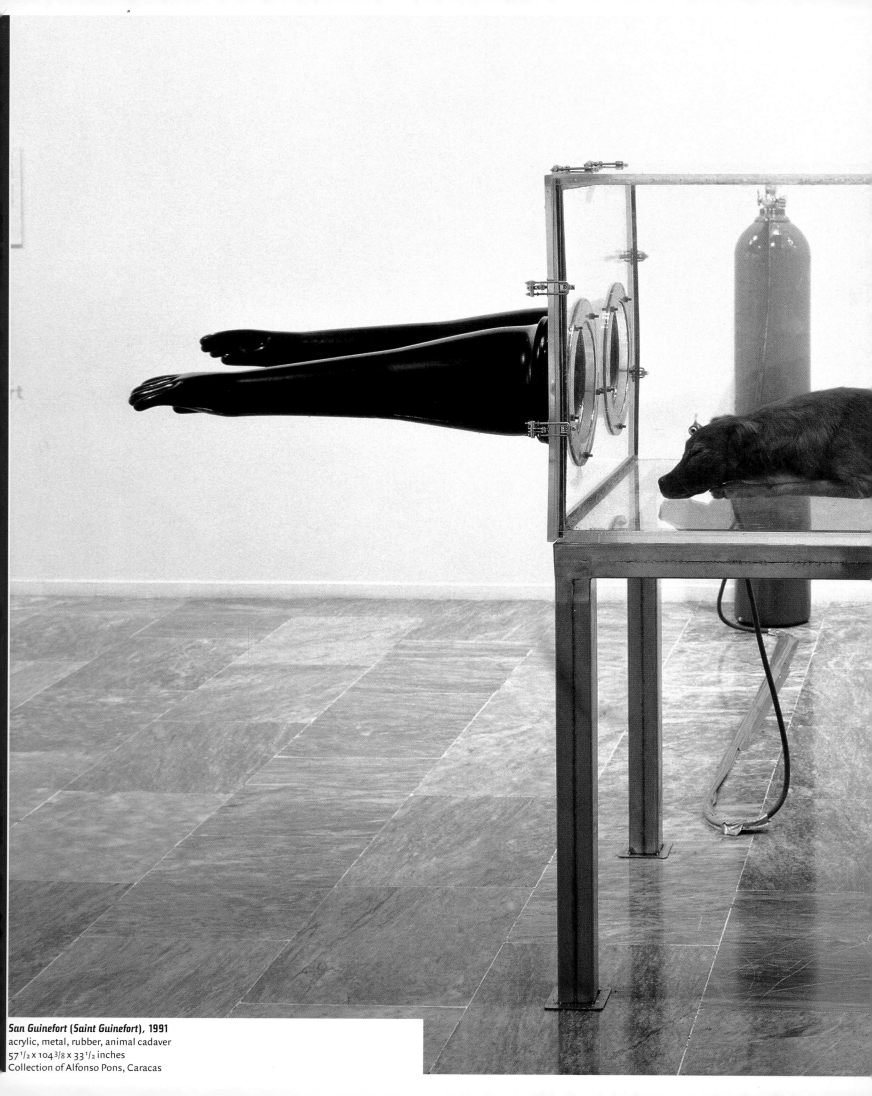

San Guinefort (Saint Guinefort), 1991
acrylic, metal, rubber, animal cadaver
57 1/2 x 104 3/8 x 33 1/2 inches
Collection of Alfonso Pons, Caracas

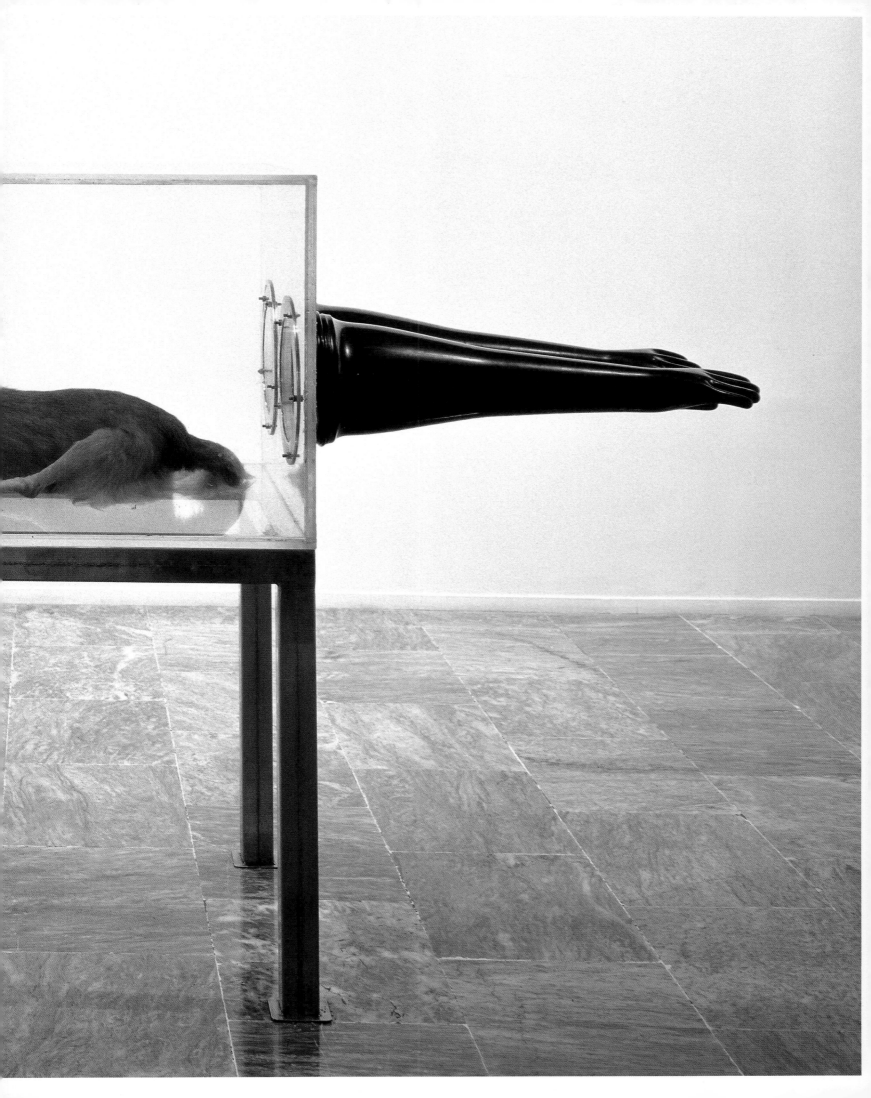

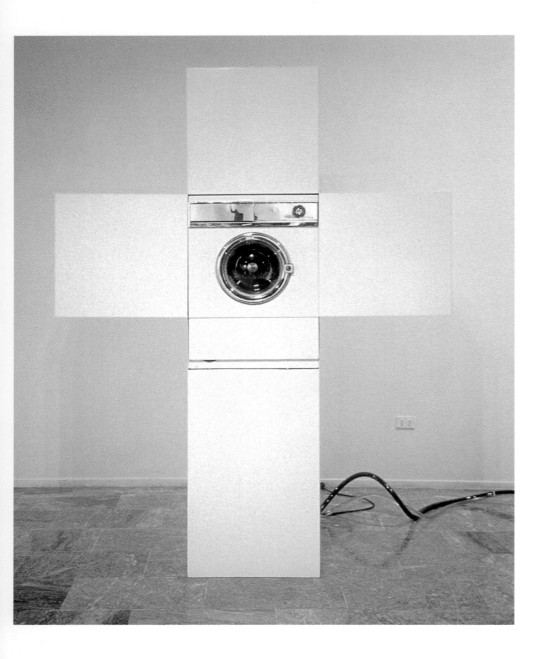

***Lavarás tus pecados* (*You Shall Wash Your Sins*), 1991**
mixed media
94 1/2 x 70 7/8 x 20 1/2 inches
Courtesy of Museo Acariqua-Aruare, Venezuela

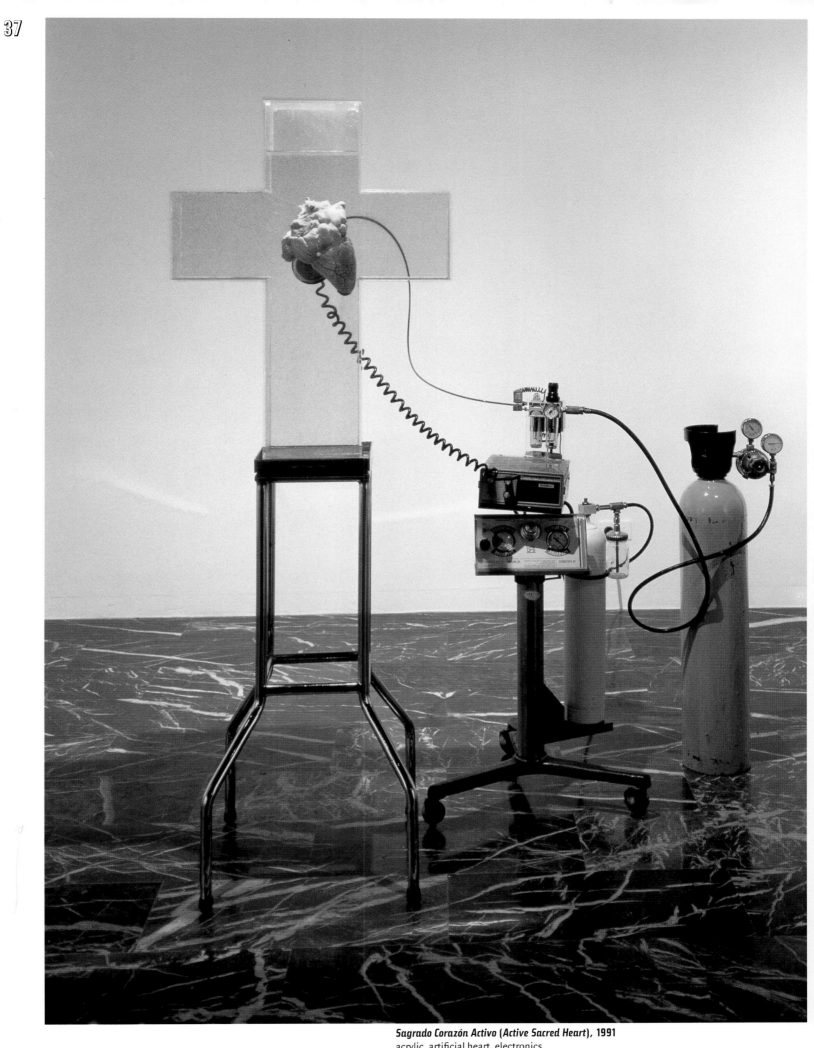

Sagrado Corazón Activo (Active Sacred Heart), 1991
acrylic, artificial heart, electronics
dimensions variable
Courtesy of the artist

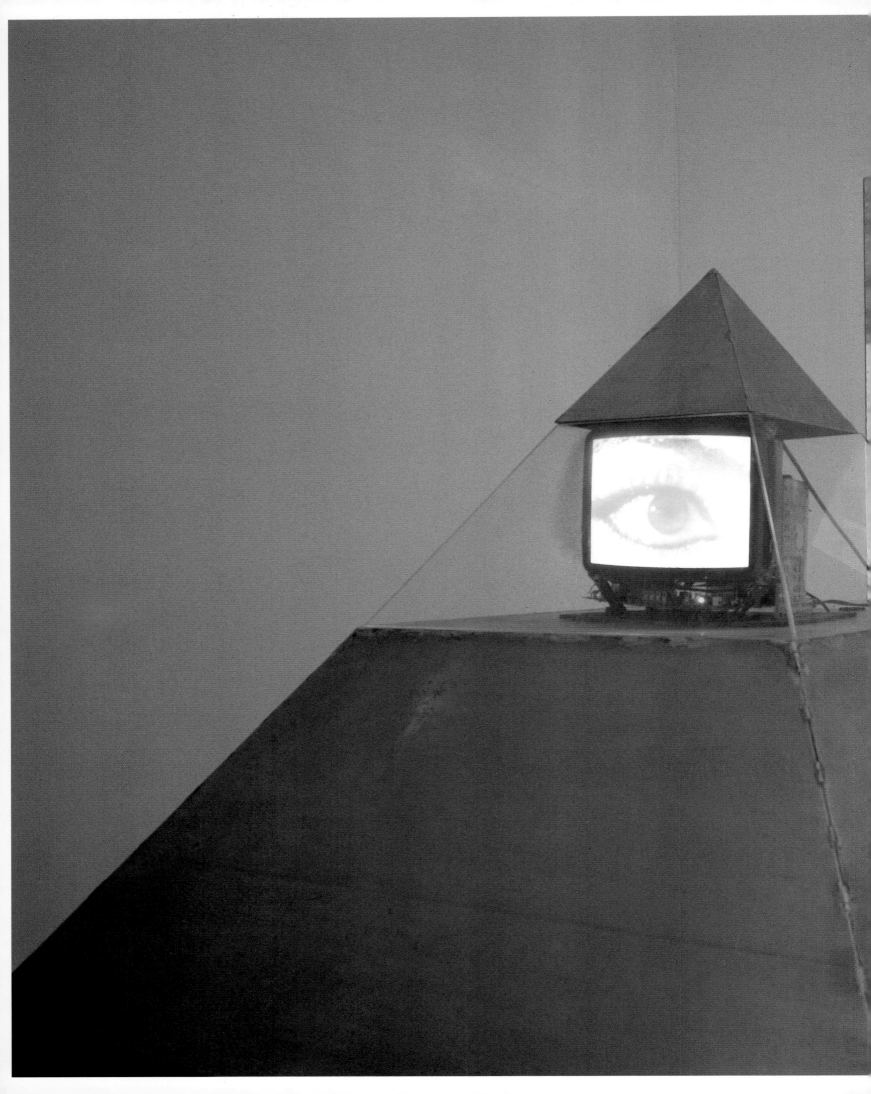

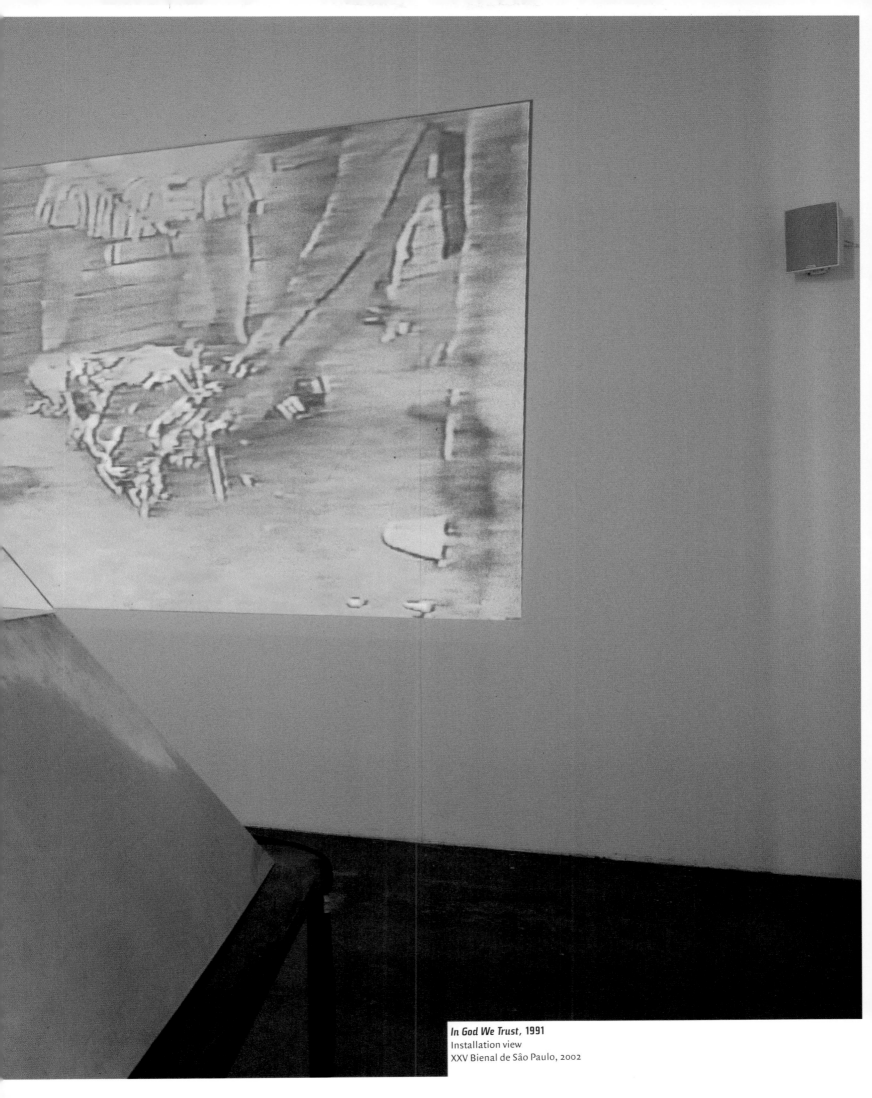

In God We Trust, 1991
Installation view
XXV Bienal de Sâo Paulo, 2002

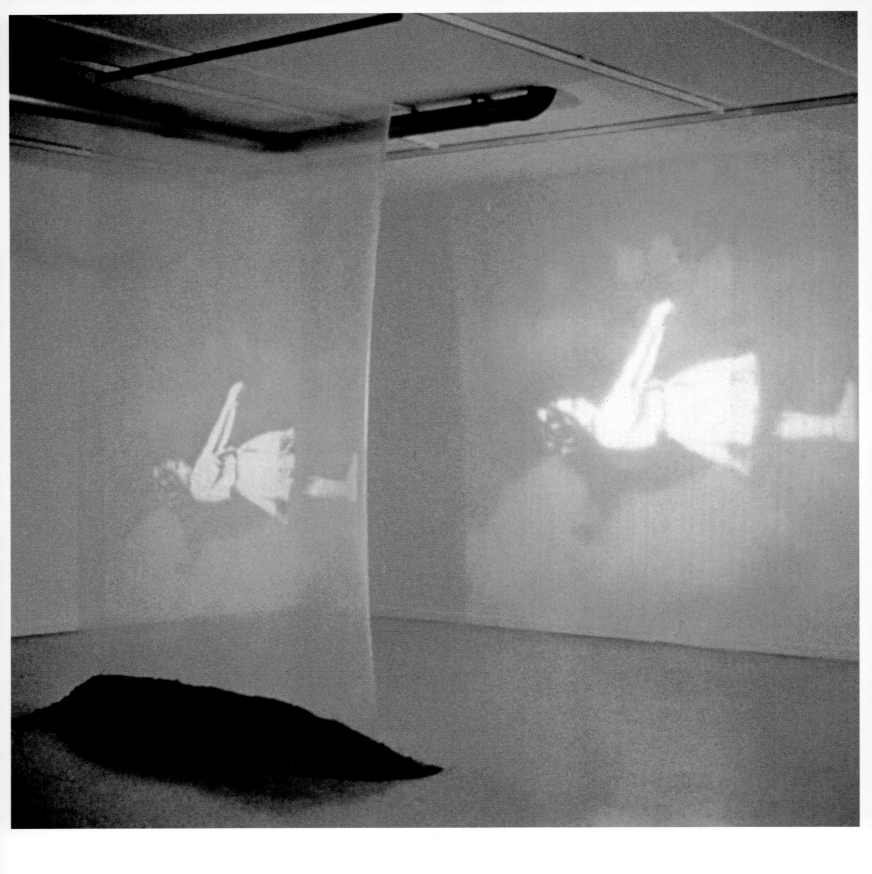

*Vas p'al cielo y vas llorando (**You Go to Heaven and You Go Crying**), 1992*
video projection, screen, dirt
dimensions variable
Collection of Rosa and Carlos de la Cruz, Miami

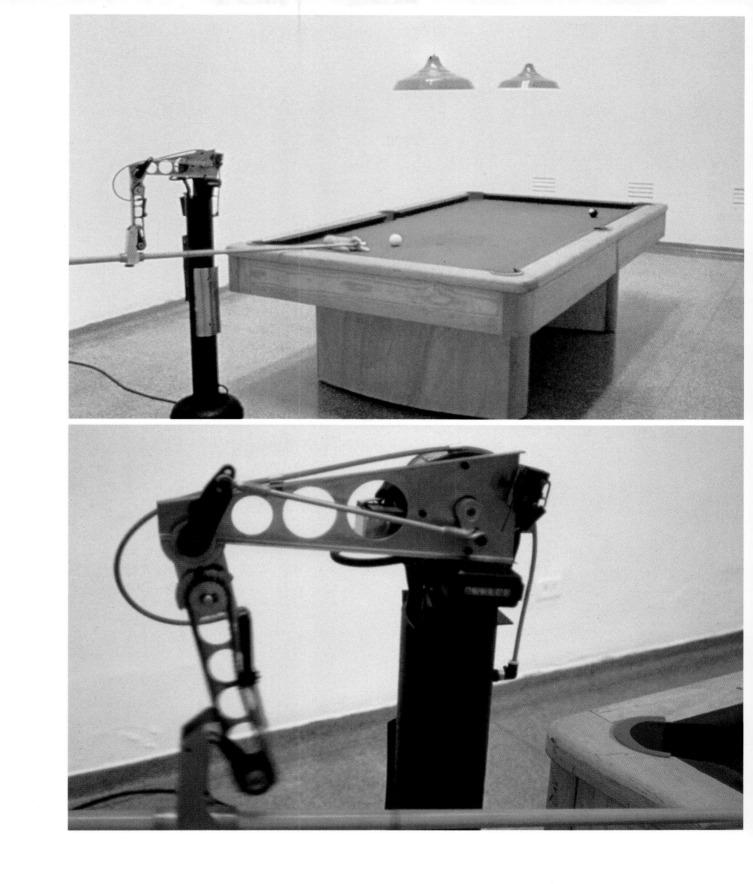

El Gran Patriarca (The Grand Patriarch), 1993
pool table, mechanical arm
55 7/8 x 100 x 31 1/8 inches (pool table), 9 7/8 x 59 x 9 7/8 inches (arm)
Courtesy of the artist, Barcelona

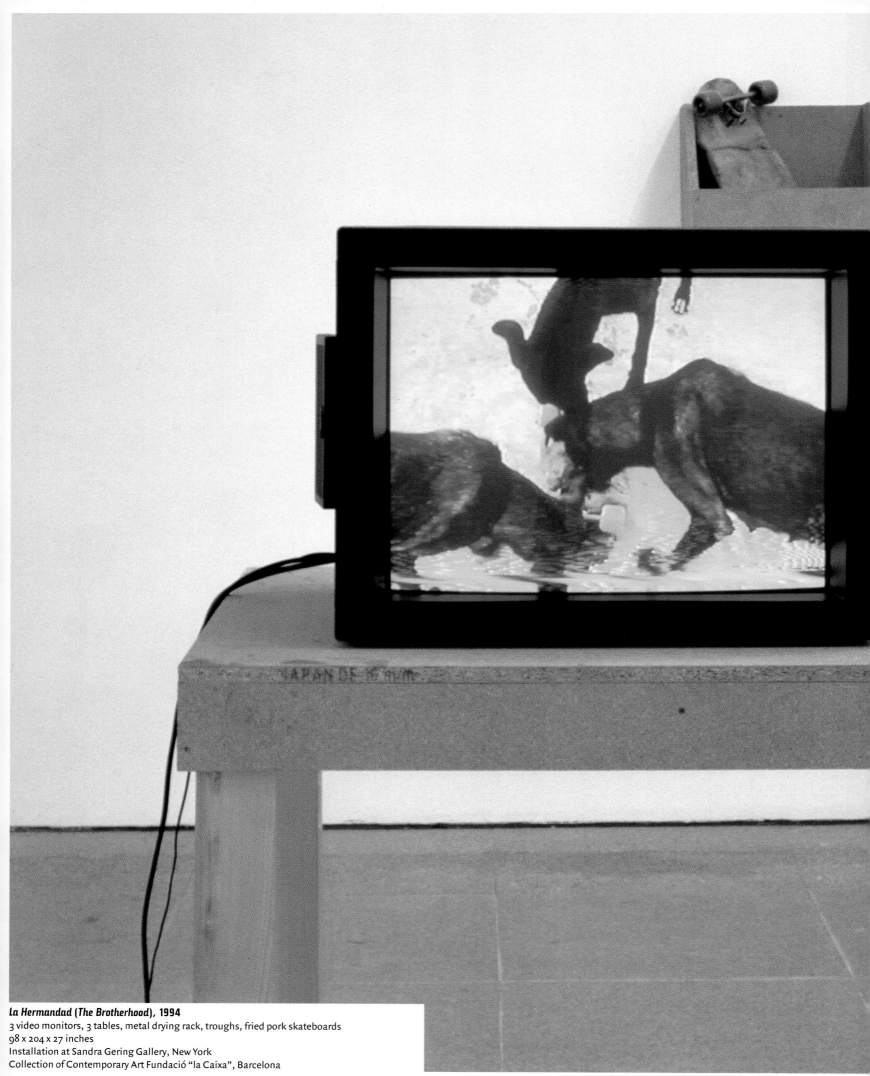

La Hermandad (The Brotherhood), 1994
3 video monitors, 3 tables, metal drying rack, troughs, fried pork skateboards
98 x 204 x 27 inches
Installation at Sandra Gering Gallery, New York
Collection of Contemporary Art Fundació "la Caixa", Barcelona

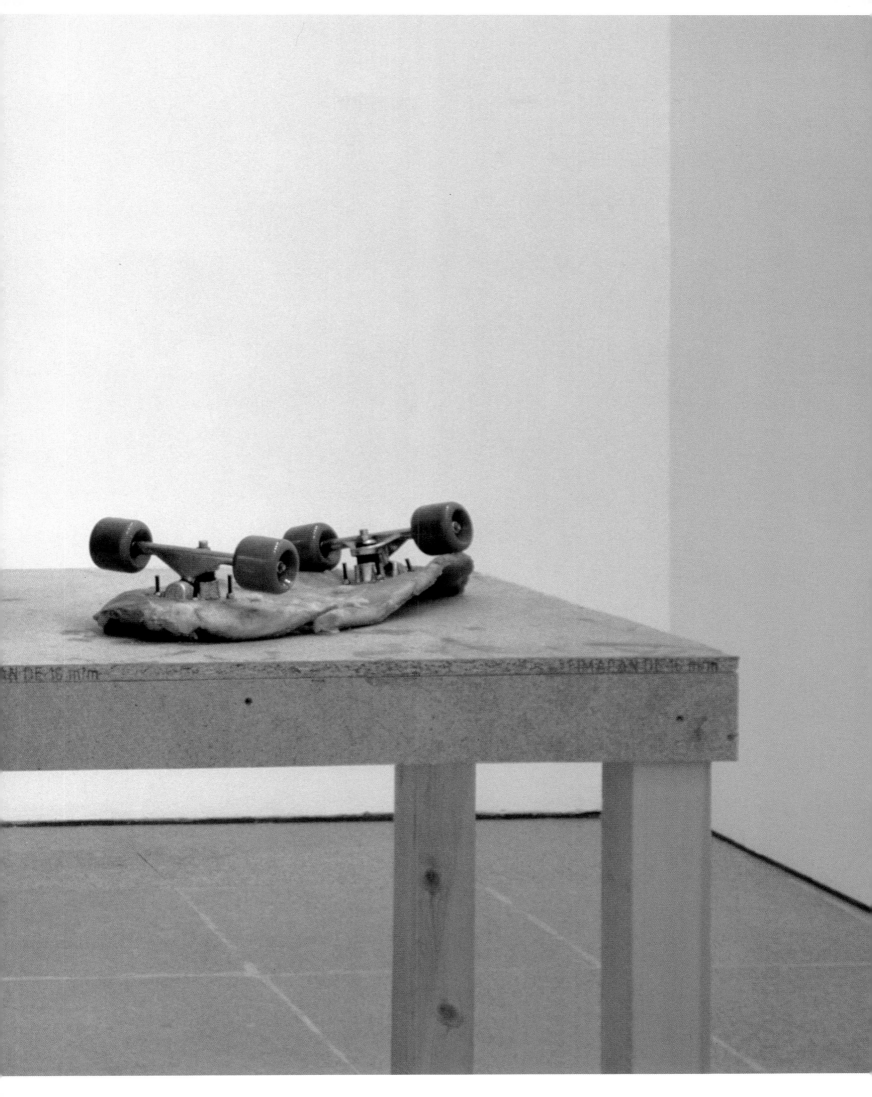

***La Hermandad (The Brotherhood)*, 1994**
3 video monitors, 3 tables, metal drying rack, troughs, fried pork skateboards
98 x 204 x 27 inches
Installation at Sandra Gering Gallery, New York
Collection of Contemporary Art Fundació "la Caixa", Barcelona

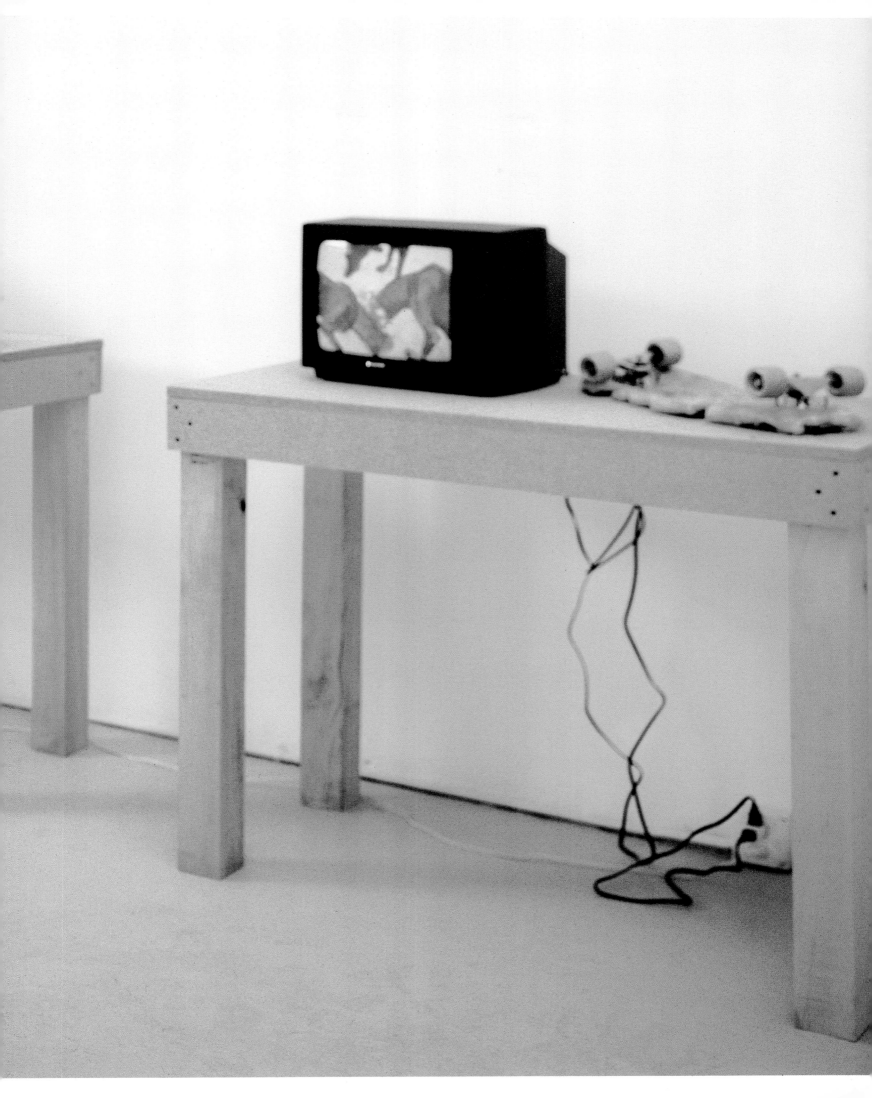

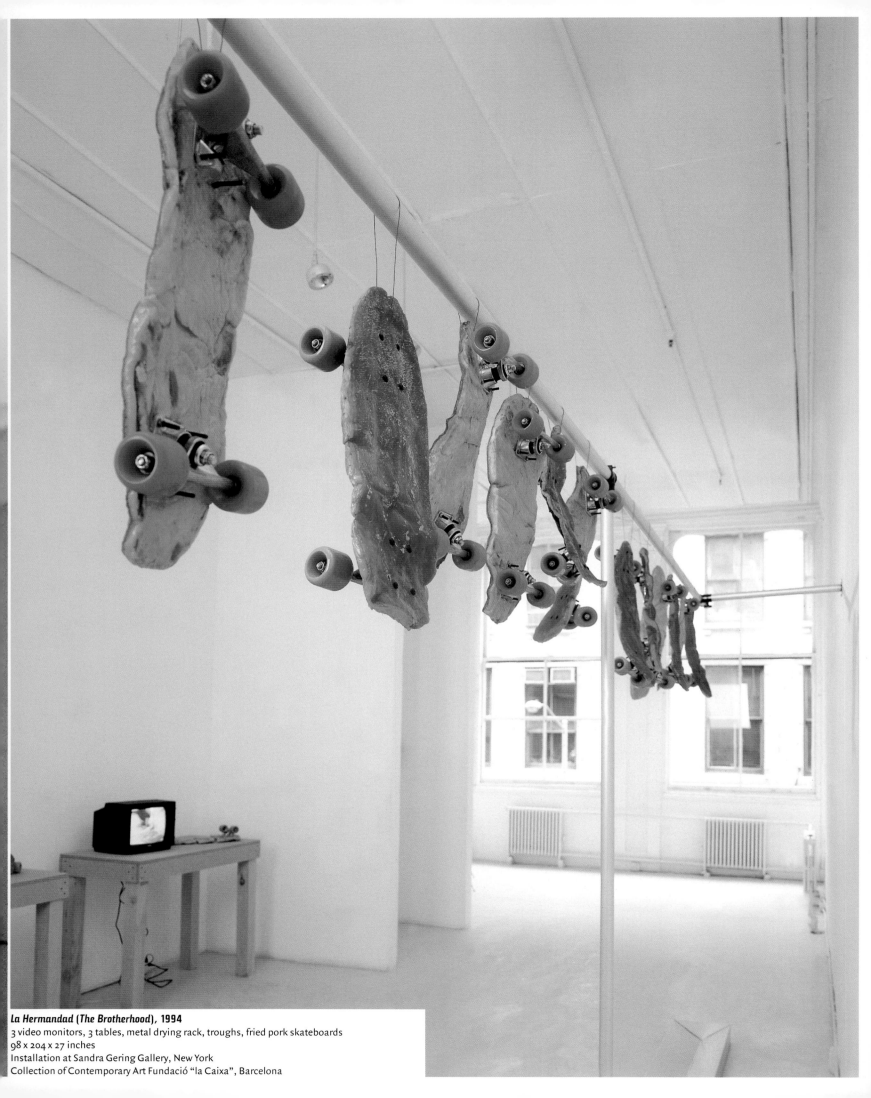

La Hermandad (The Brotherhood), 1994
3 video monitors, 3 tables, metal drying rack, troughs, fried pork skateboards
98 x 204 x 27 inches
Installation at Sandra Gering Gallery, New York
Collection of Contemporary Art Fundació "la Caixa", Barcelona

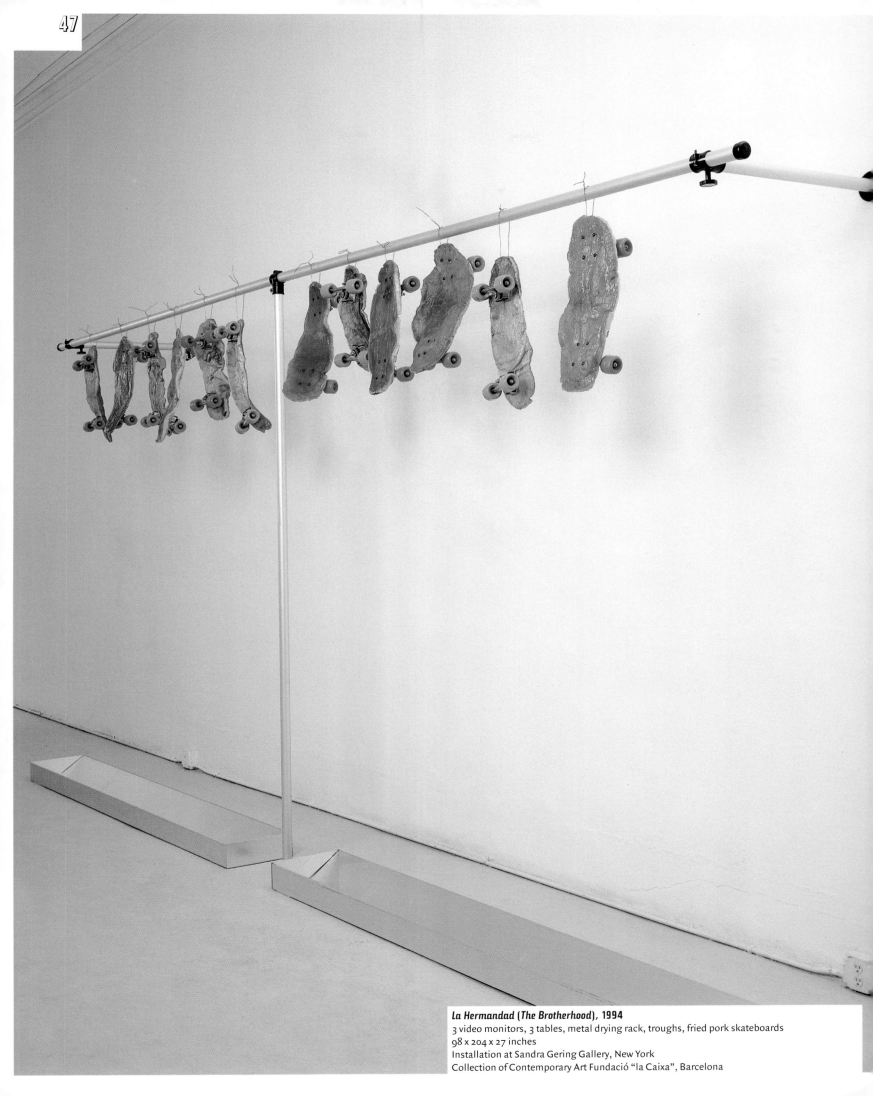

La Hermandad (The Brotherhood), 1994
3 video monitors, 3 tables, metal drying rack, troughs, fried pork skateboards
98 x 204 x 27 inches
Installation at Sandra Gering Gallery, New York
Collection of Contemporary Art Fundació "la Caixa", Barcelona

La Hermandad (The Brotherhood), **1994**
3 video monitors, 3 tables, metal drying rack, troughs, fried pork skateboards
98 x 204 x 27 inches
Installation at Sandra Gering Gallery, New York
Collection of Contemporary Art Fundació "la Caixa", Barcelona

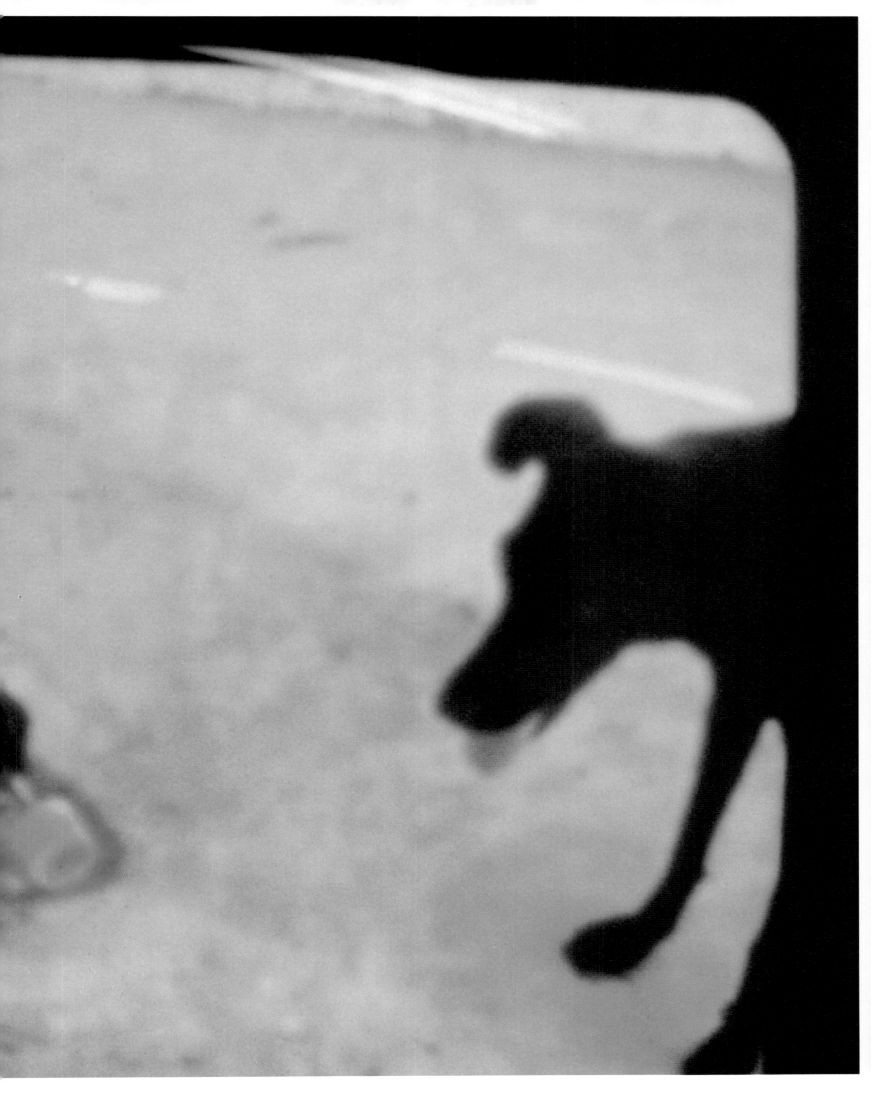

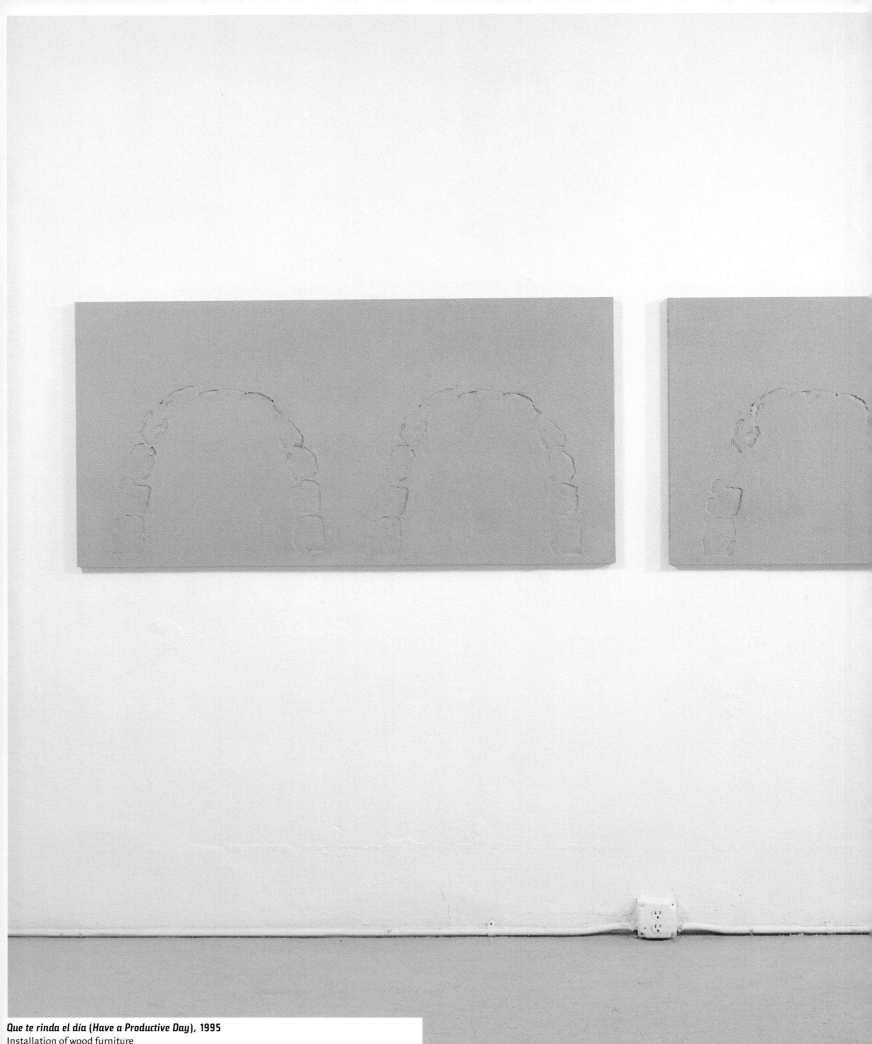

Que te rinda el día (Have a Productive Day), **1995**
Installation of wood furniture
Detail: triptych, 59 x 31 ¹/₂ inches each
Courtesy of Sandra Gering Gallery, New York

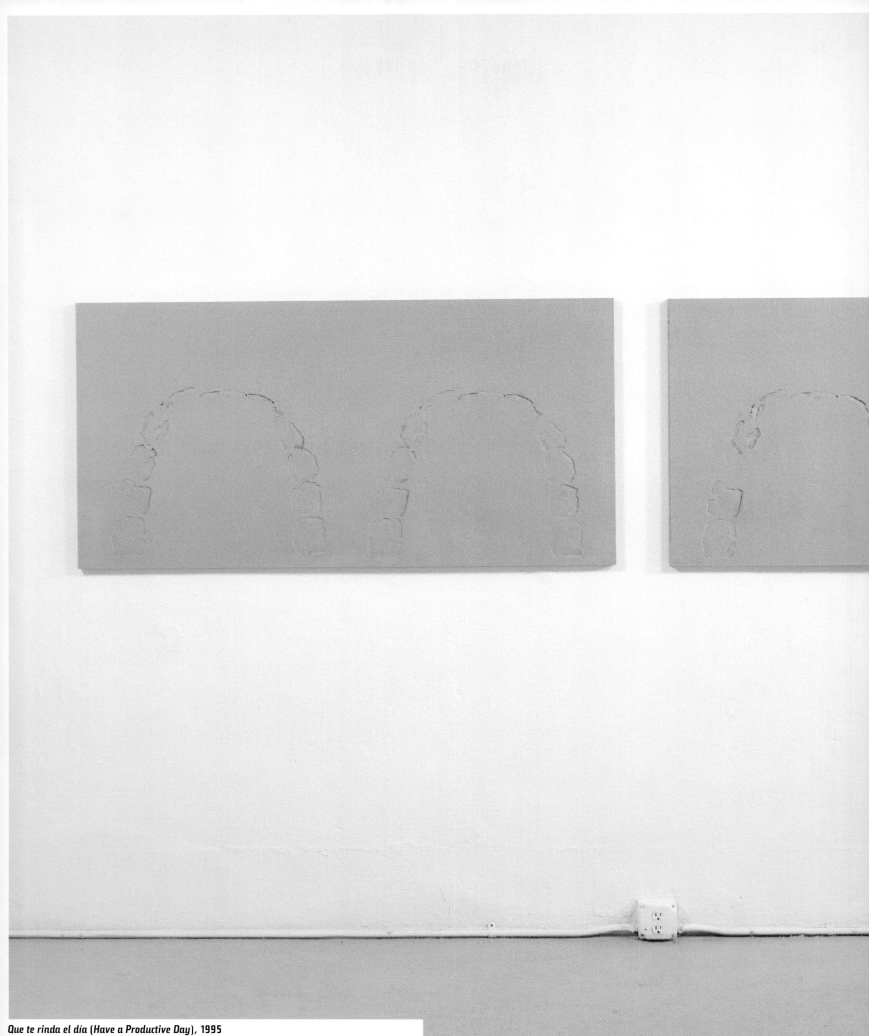

***Que te rinda el día** (Have a Productive Day)*, **1995**
Installation of wood furniture
Detail: triptych, 59 x 31$^1/_2$ inches each
Courtesy of Sandra Gering Gallery, New York

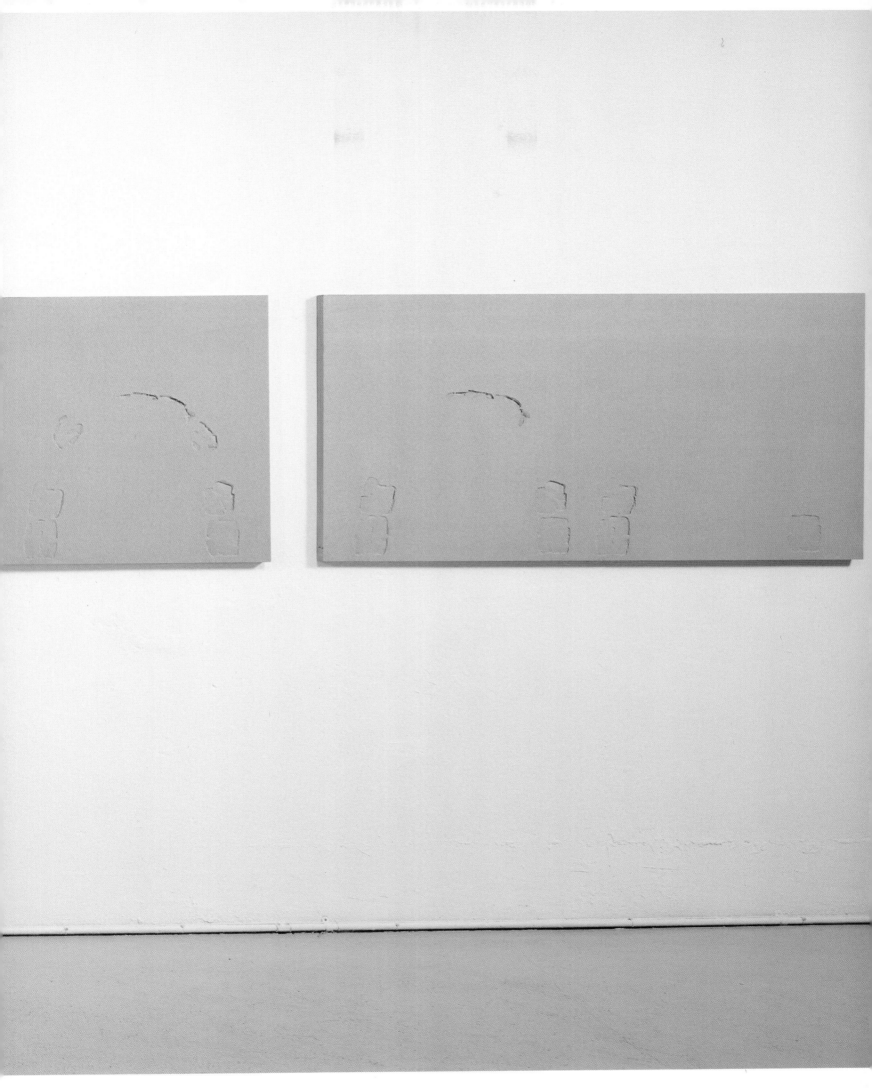

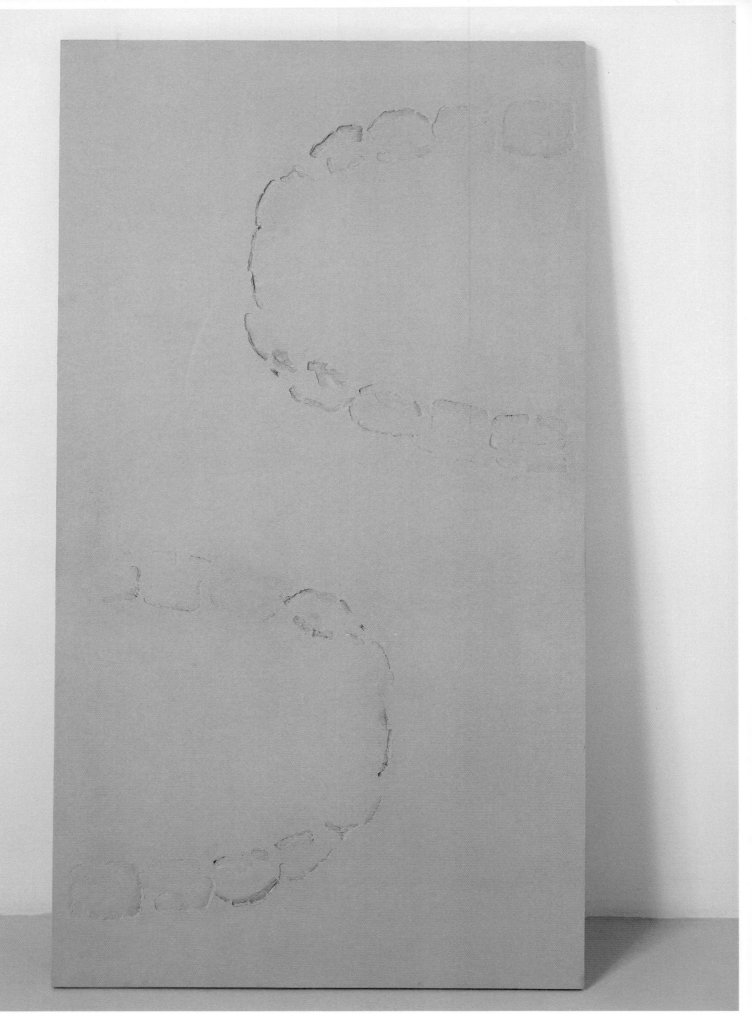

Que te rinda el día (*Have a Productive Day*), 1995
Installation of wood furniture
Detail: panel, 59 x 31 ¹/₂ inches each
Courtesy of Sandra Gering Gallery, New York

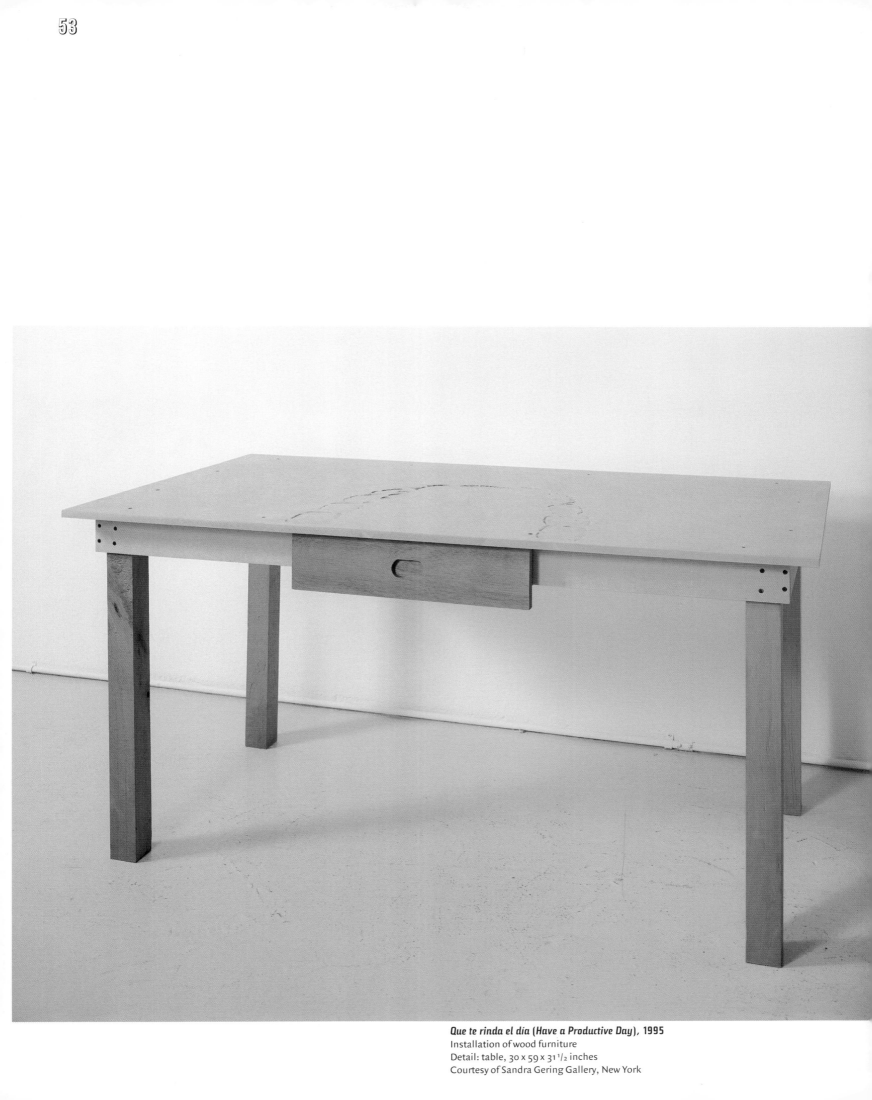

*Que te rinda el día (**Have a Productive Day**)*, 1995
Installation of wood furniture
Detail: table, 30 x 59 x 31 1/2 inches
Courtesy of Sandra Gering Gallery, New York

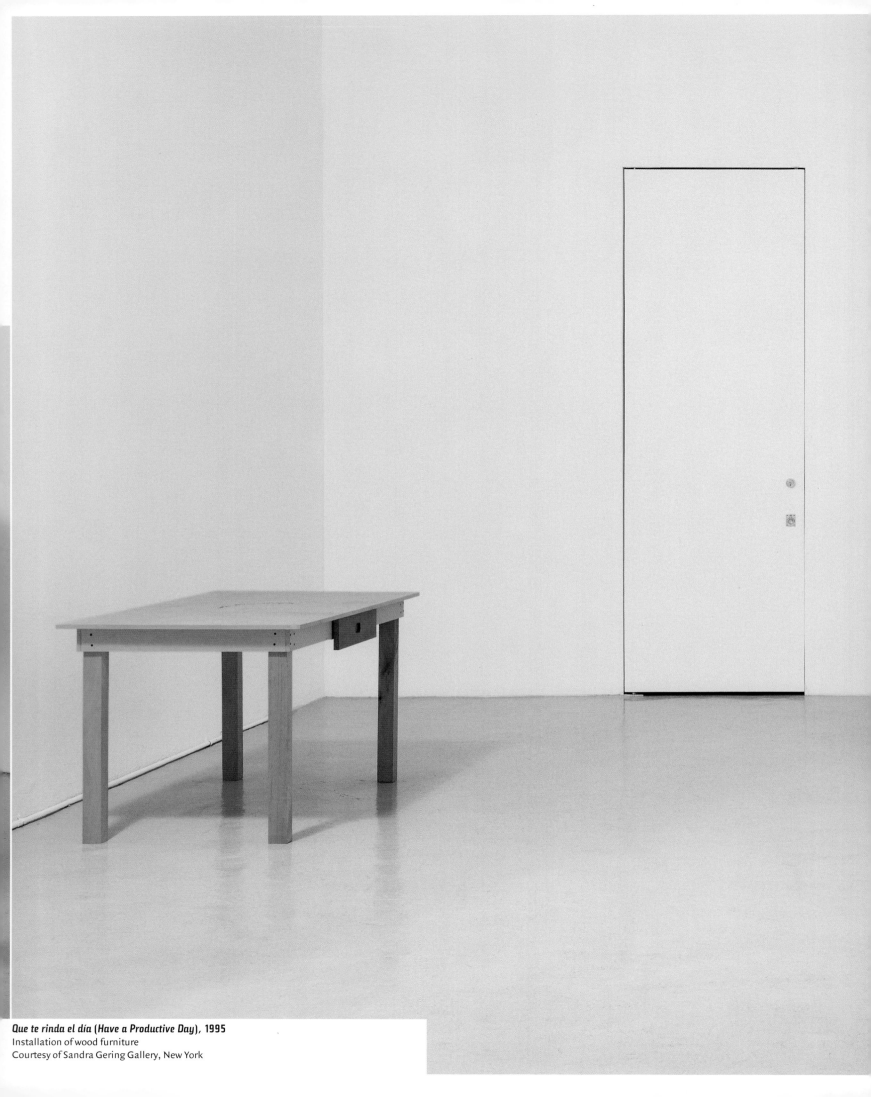

Que te rinda el día (*Have a Productive Day*), 1995
Installation of wood furniture
Courtesy of Sandra Gering Gallery, New York

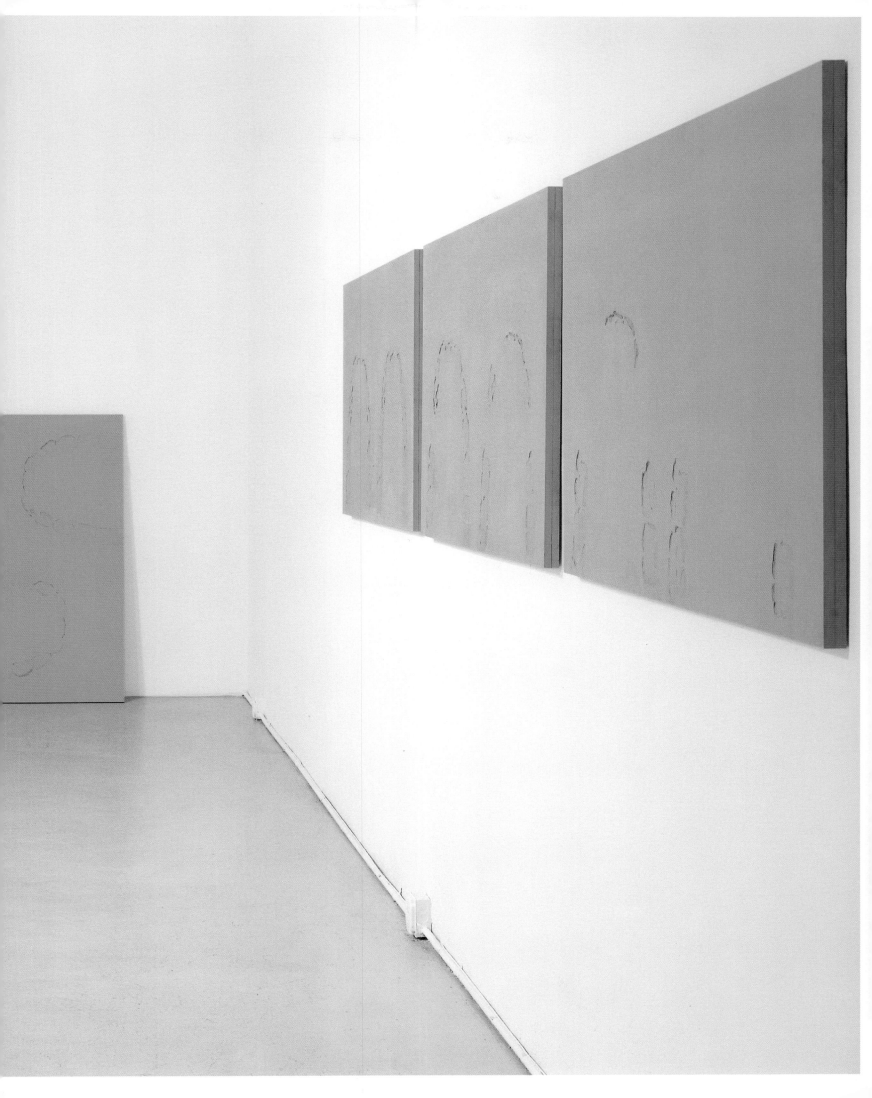

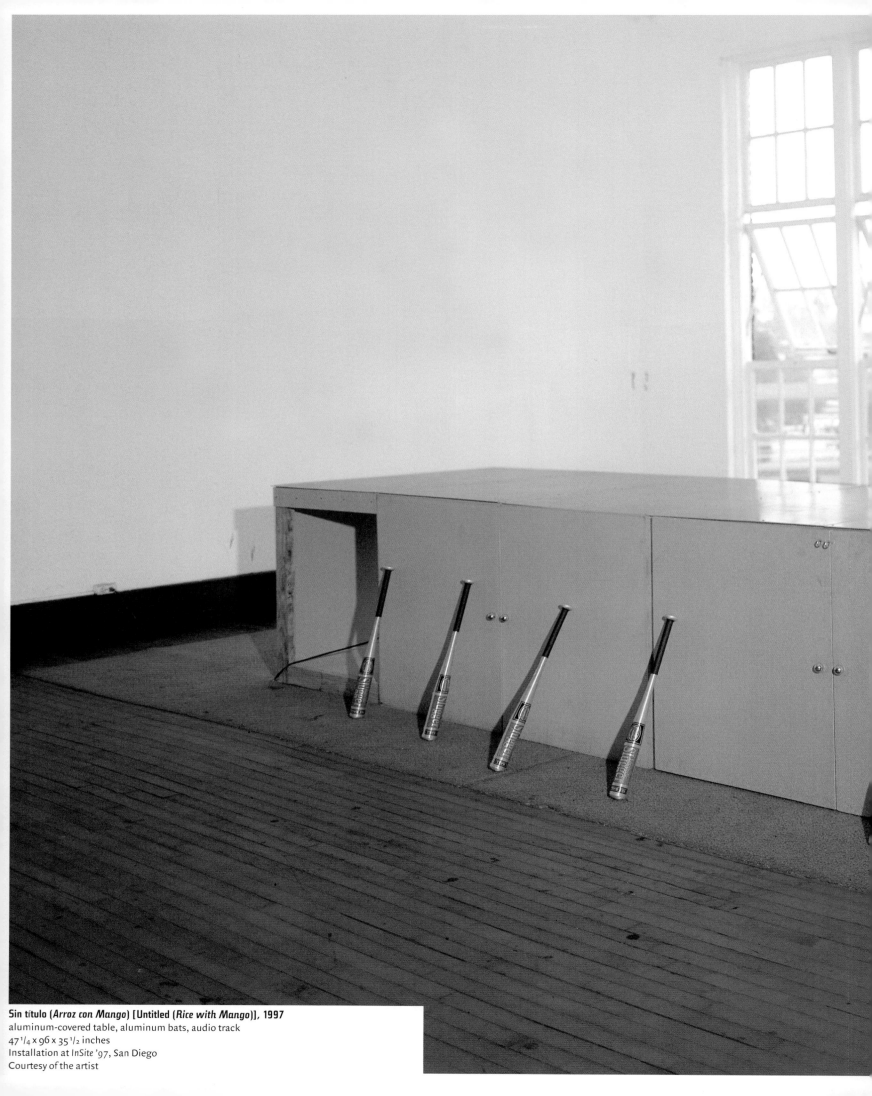

Sin título (*Arroz con Mango*) [Untitled (*Rice with Mango*)], 1997
aluminum-covered table, aluminum bats, audio track
47 1/4 x 96 x 35 1/2 inches
Installation at *InSite* '97, San Diego
Courtesy of the artist

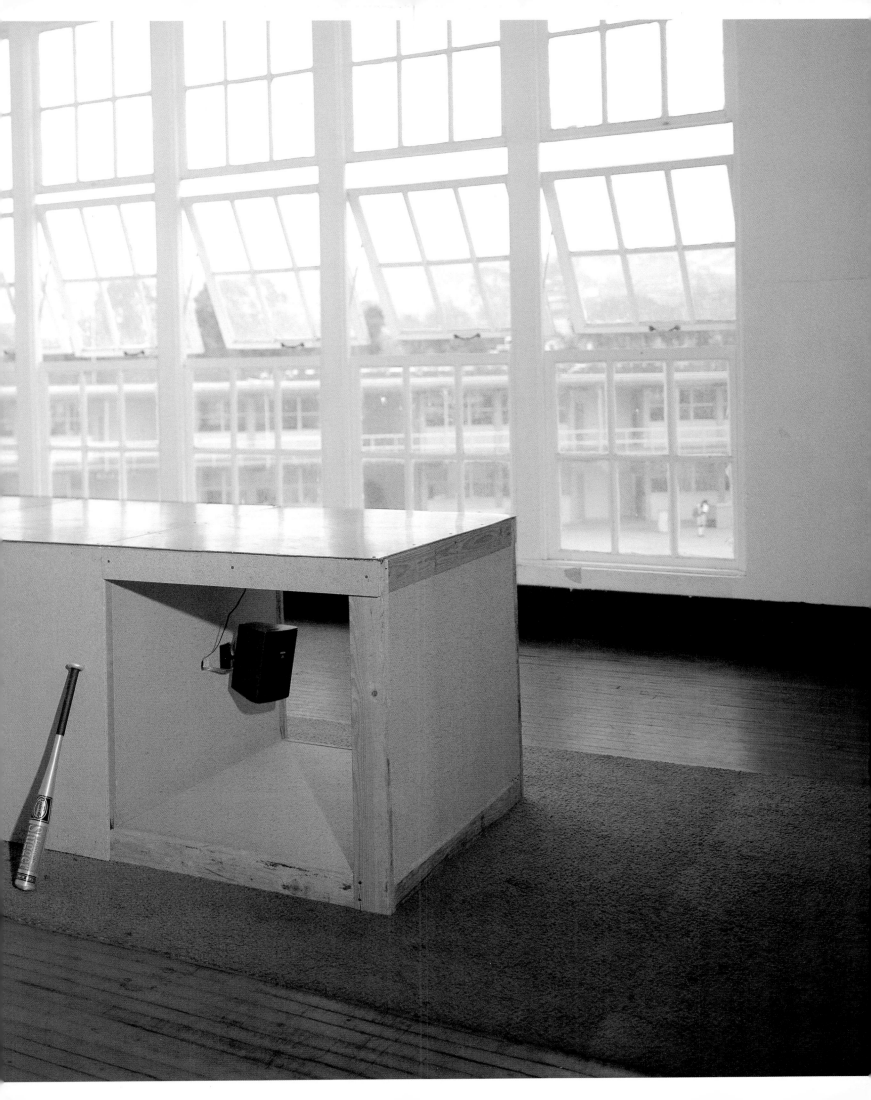

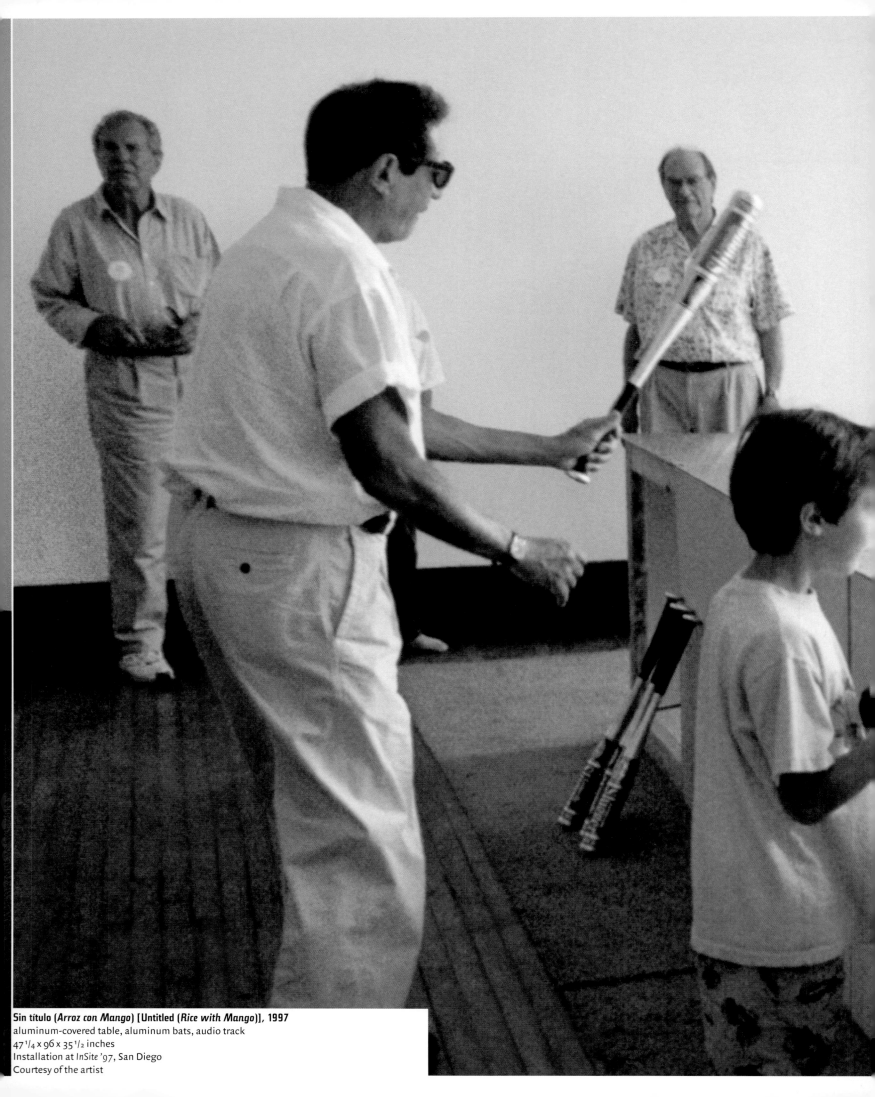

Sin título (*Arroz con Mango*) [Untitled (*Rice with Mango*)], 1997
aluminum-covered table, aluminum bats, audio track
47¹/₄ x 96 x 35¹/₂ inches
Installation at *InSite* '97, San Diego
Courtesy of the artist

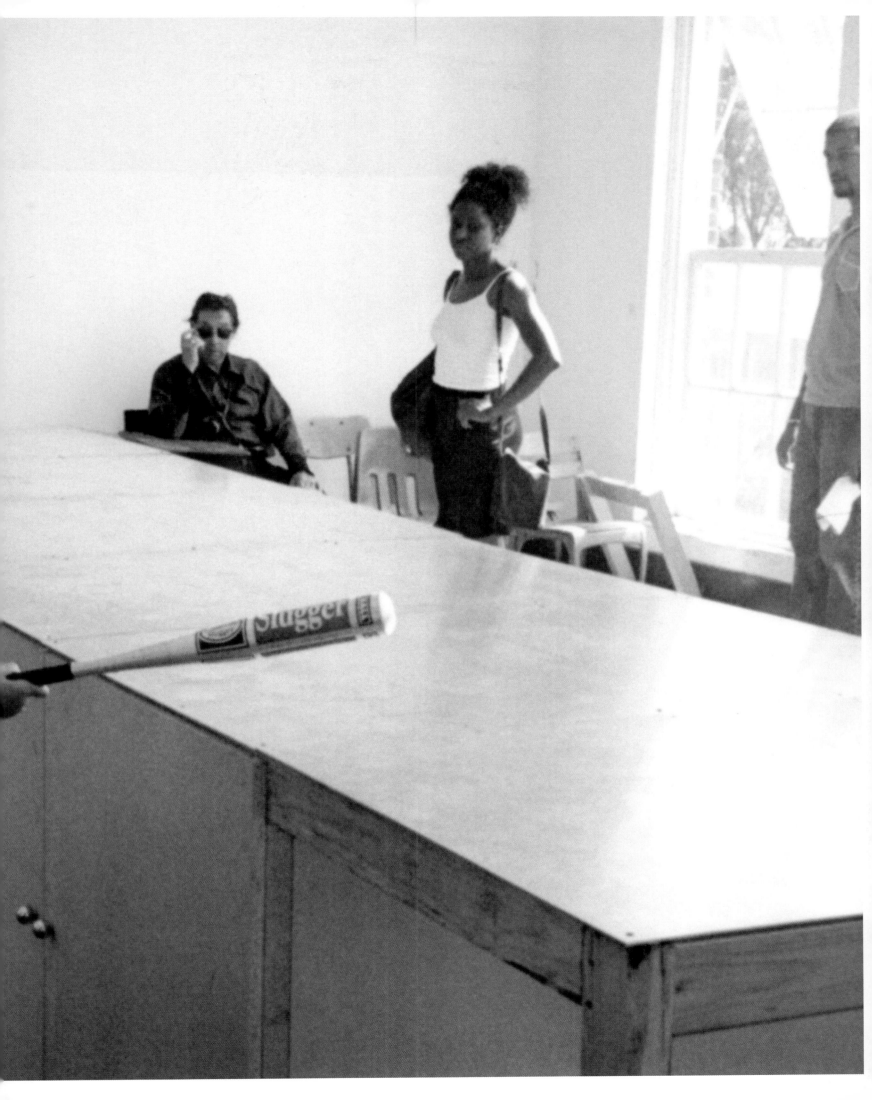

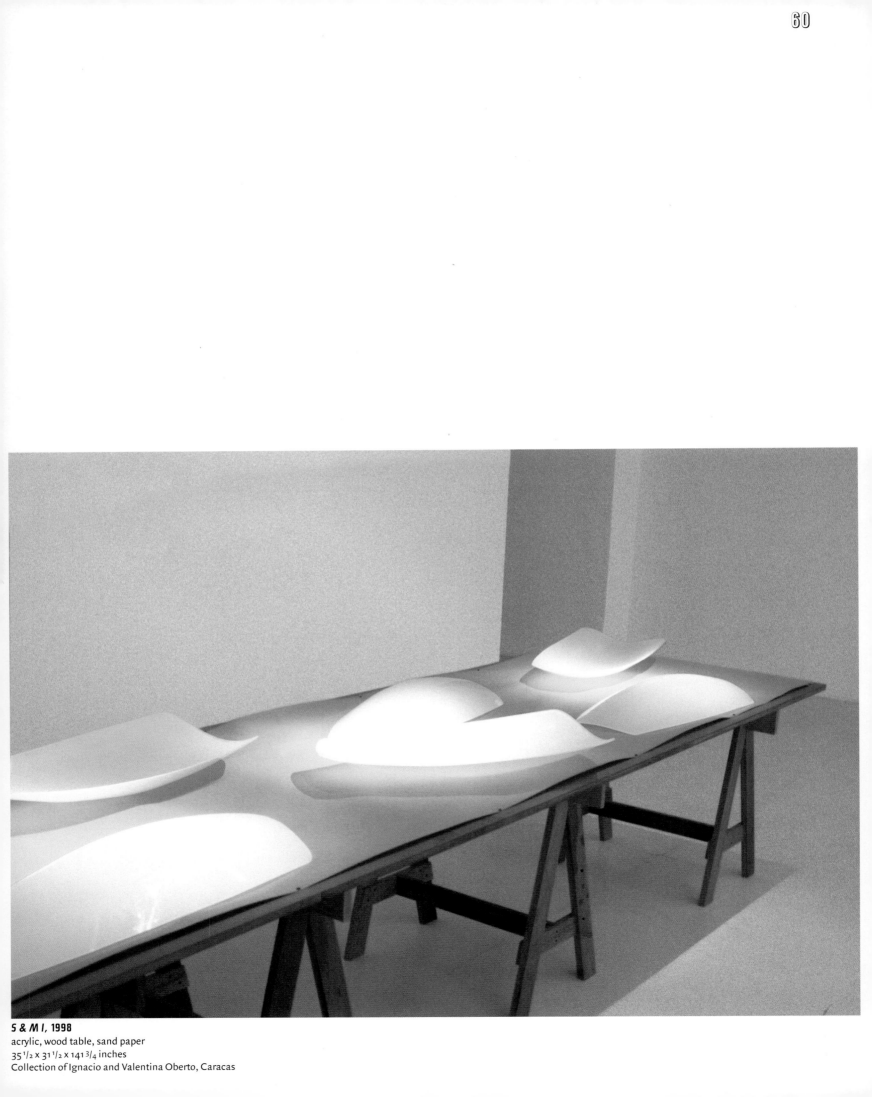

S & M I, 1998
acrylic, wood table, sand paper
35 1/2 x 31 1/2 x 141 3/4 inches
Collection of Ignacio and Valentina Oberto, Caracas

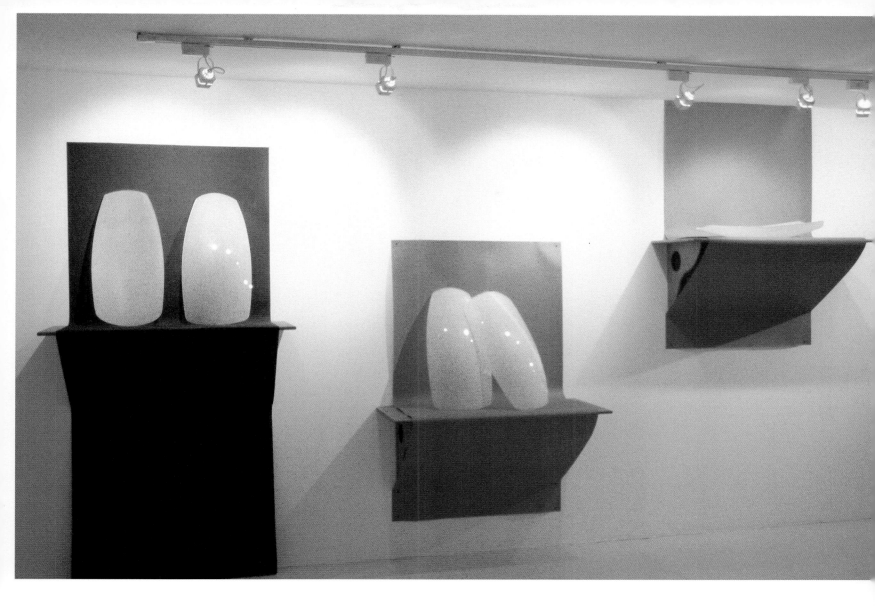

Sin título (Untitled), 1998
acrylic (nails)
dimensions variable

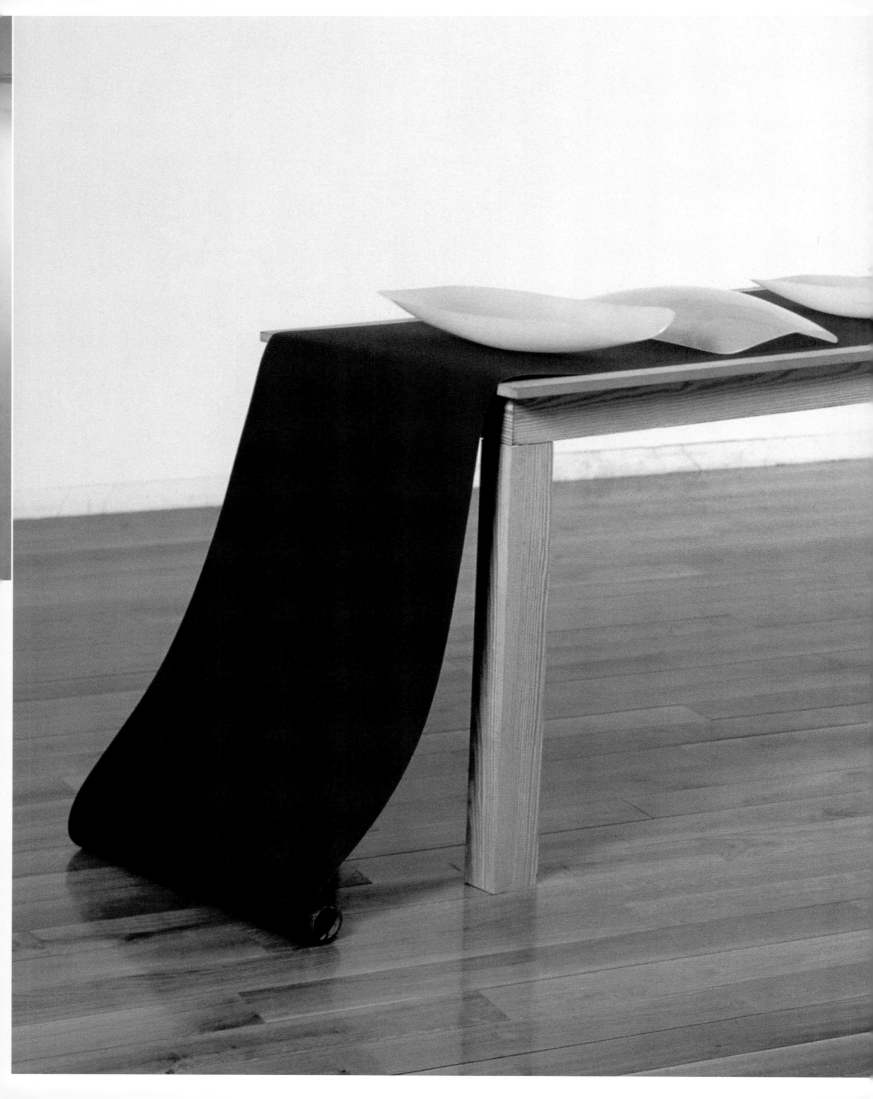

S & M II, 1998
acrylic, wood table, sand paper
35 1/2 x 31 1/2 x 14 3/4 inches
Collection Centro Galego de Arte Contemporánea (CGAC),
Santiago de Compostela

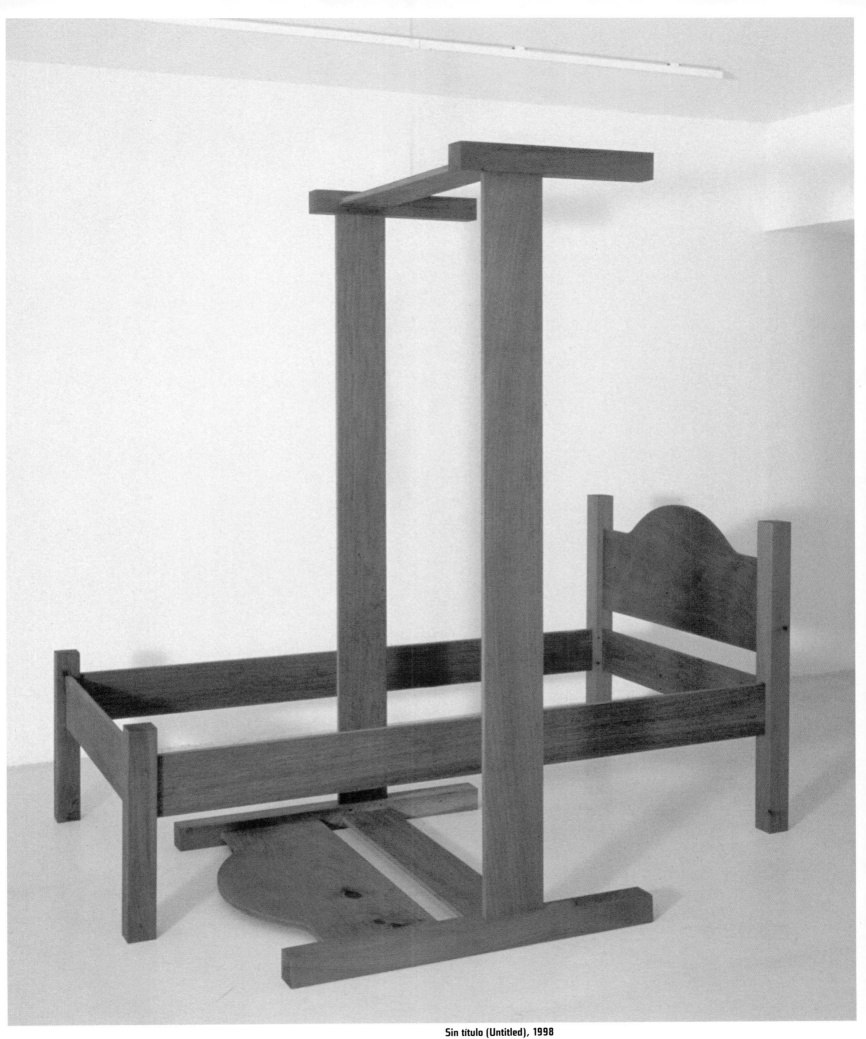

Sin título (Untitled), 1998
2 interlaced wooden pieces
78 3/4 x 78 3/4 inches

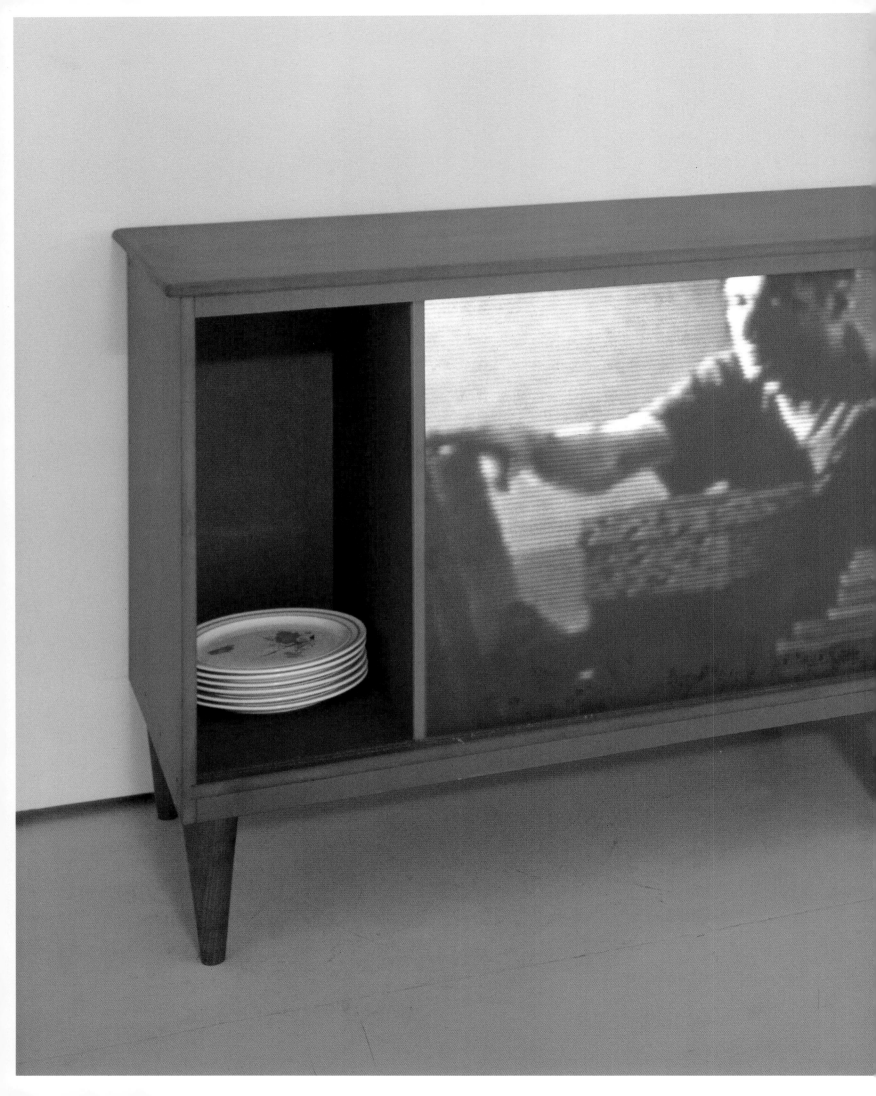

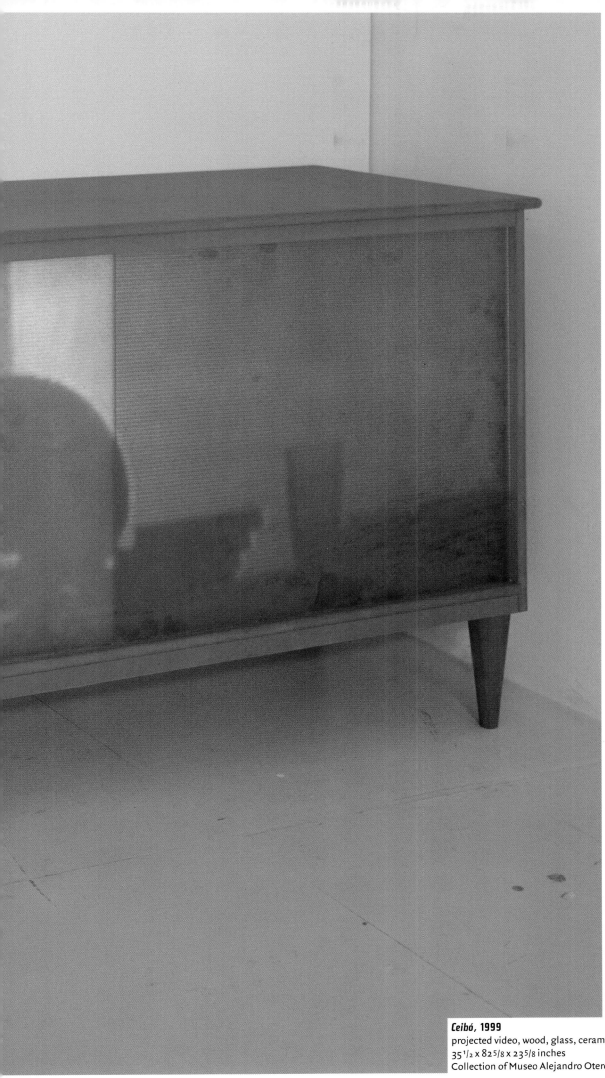

Ceibó, **1999**
projected video, wood, glass, ceramic plates
35 1/2 x 82 5/8 x 23 5/8 inches
Collection of Museo Alejandro Otero, Caracas

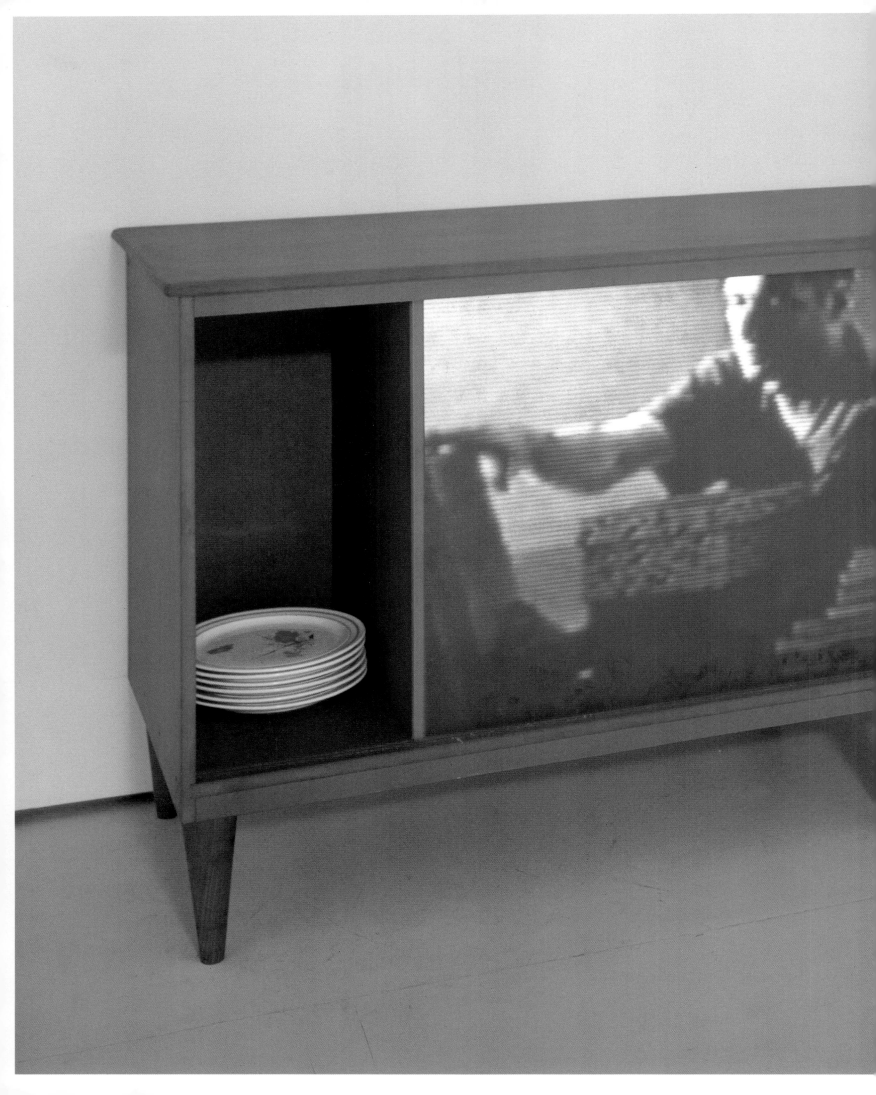

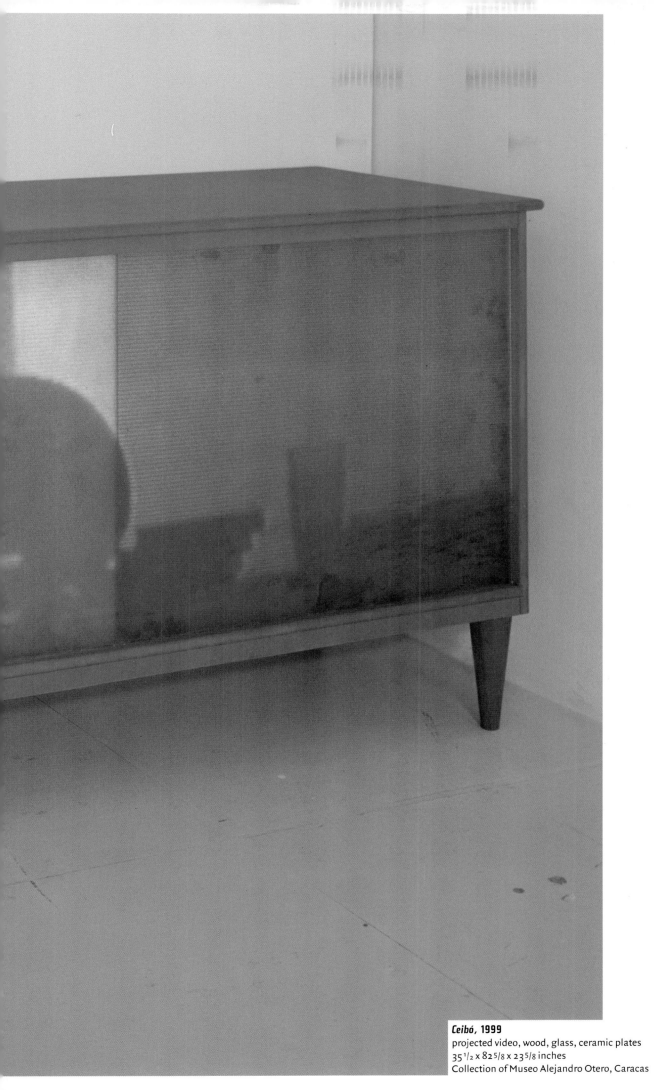

Ceibó, **1999**
projected video, wood, glass, ceramic plates
35 1/2 x 82 5/8 x 23 5/8 inches
Collection of Museo Alejandro Otero, Caracas

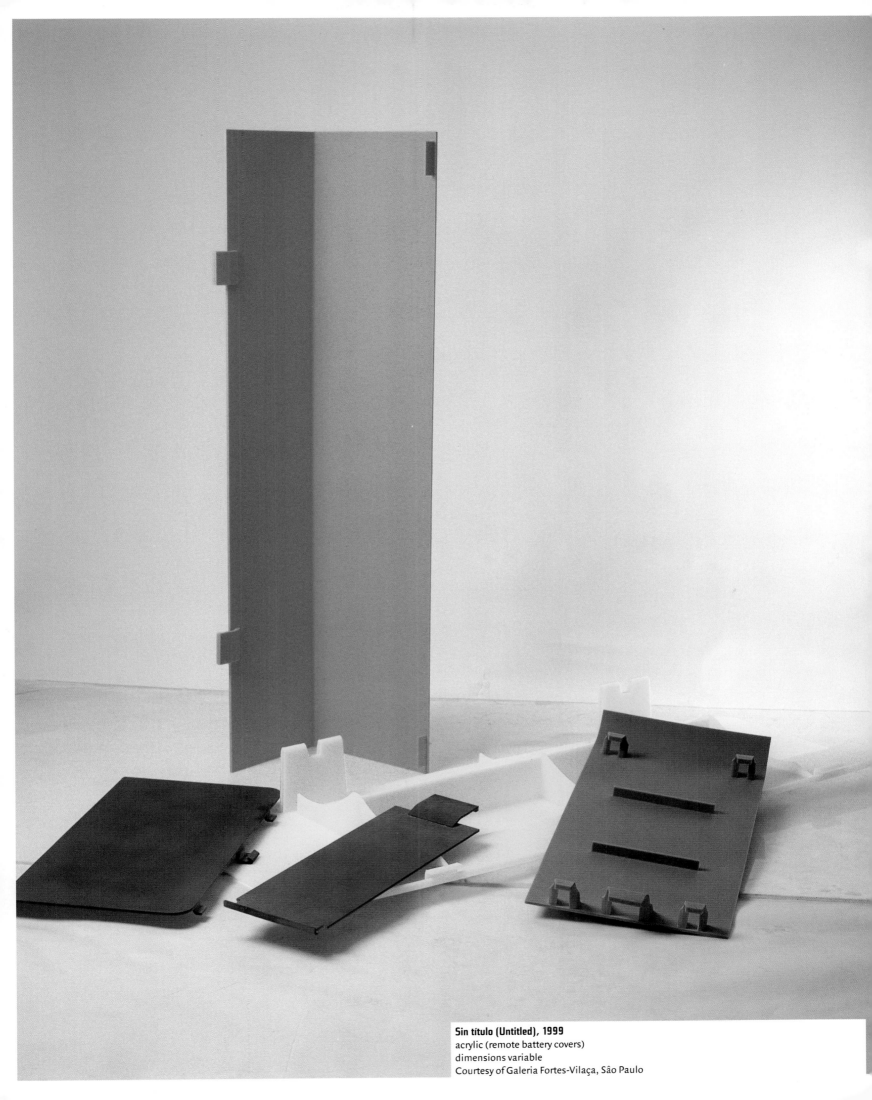

Sin título (Untitled), 1999
acrylic (remote battery covers)
dimensions variable
Courtesy of Galeria Fortes-Vilaça, São Paulo

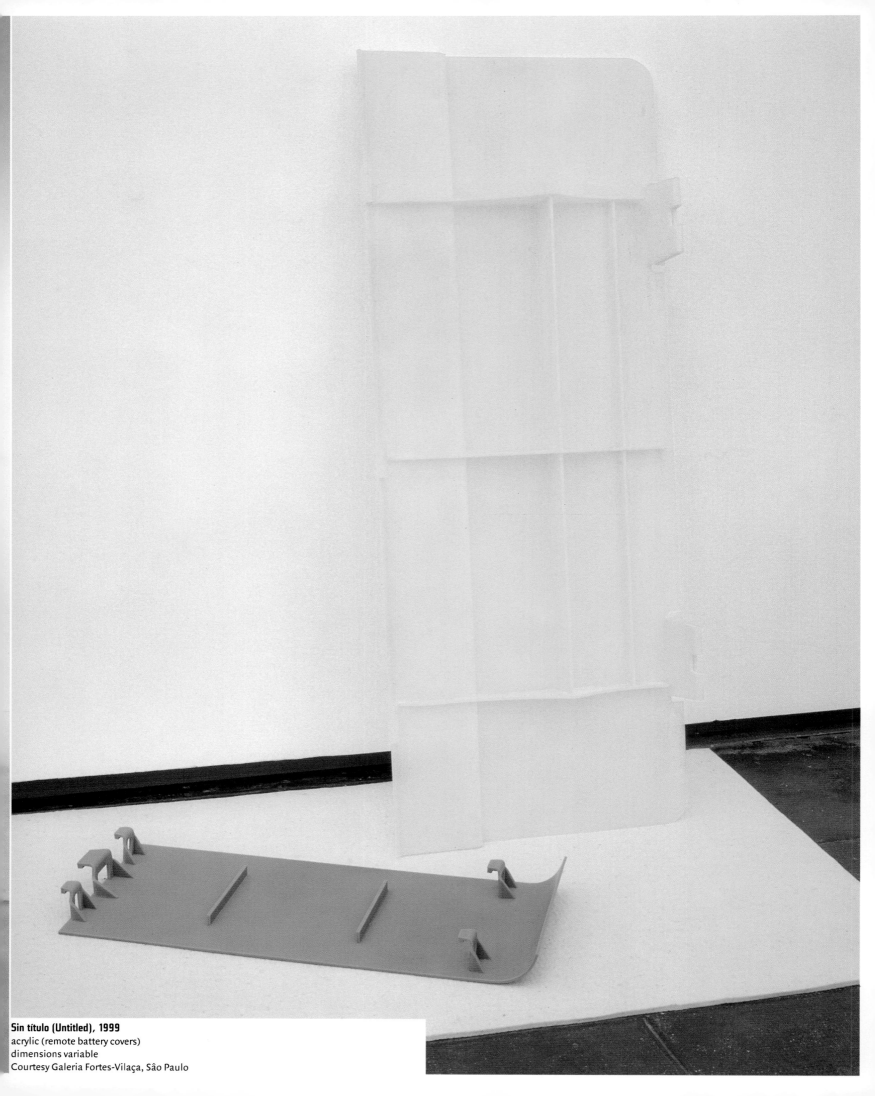

Sin título (Untitled), 1999
acrylic (remote battery covers)
dimensions variable
Courtesy Galeria Fortes-Vilaça, São Paulo

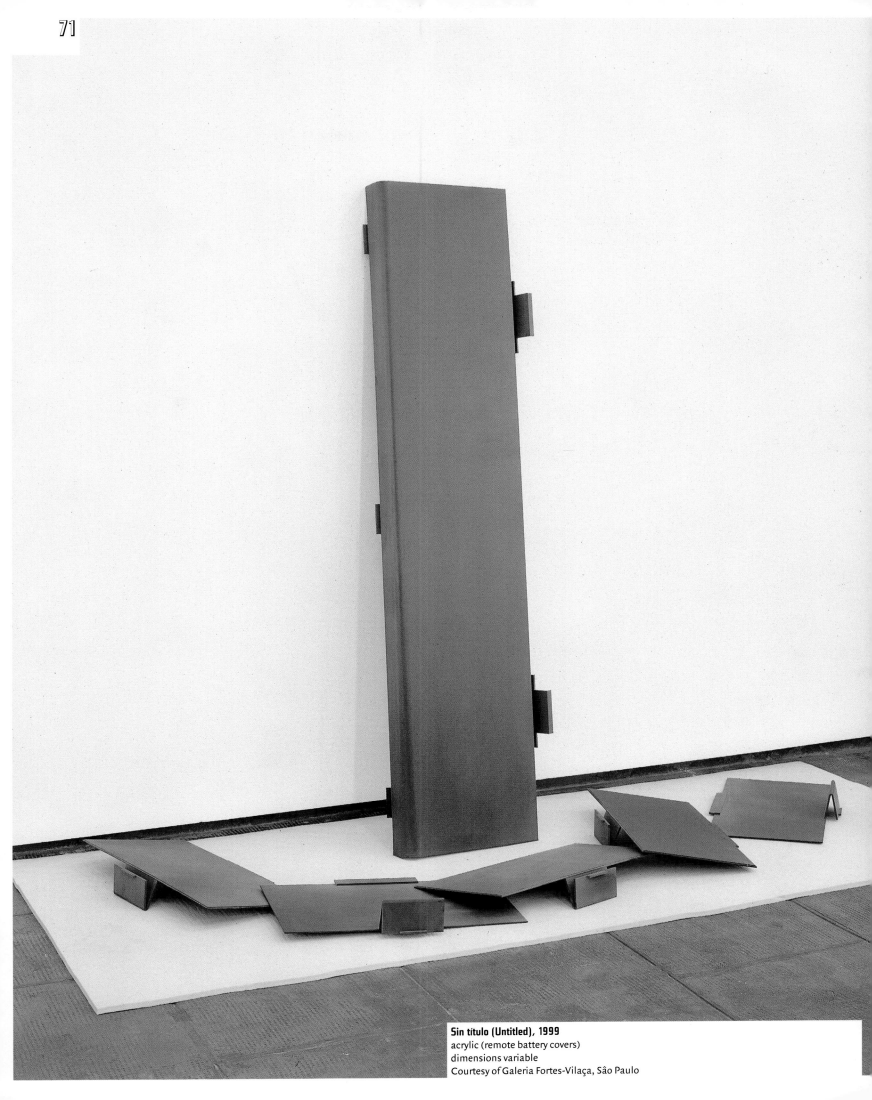

Sin título (Untitled), 1999
acrylic (remote battery covers)
dimensions variable
Courtesy of Galeria Fortes-Vilaça, Sâo Paulo

Sin título (Untitled), 2000
acrylic (spoons)
dimensions variable
Installation at CGAC, Santiago de Compostela
Courtesy of the artist

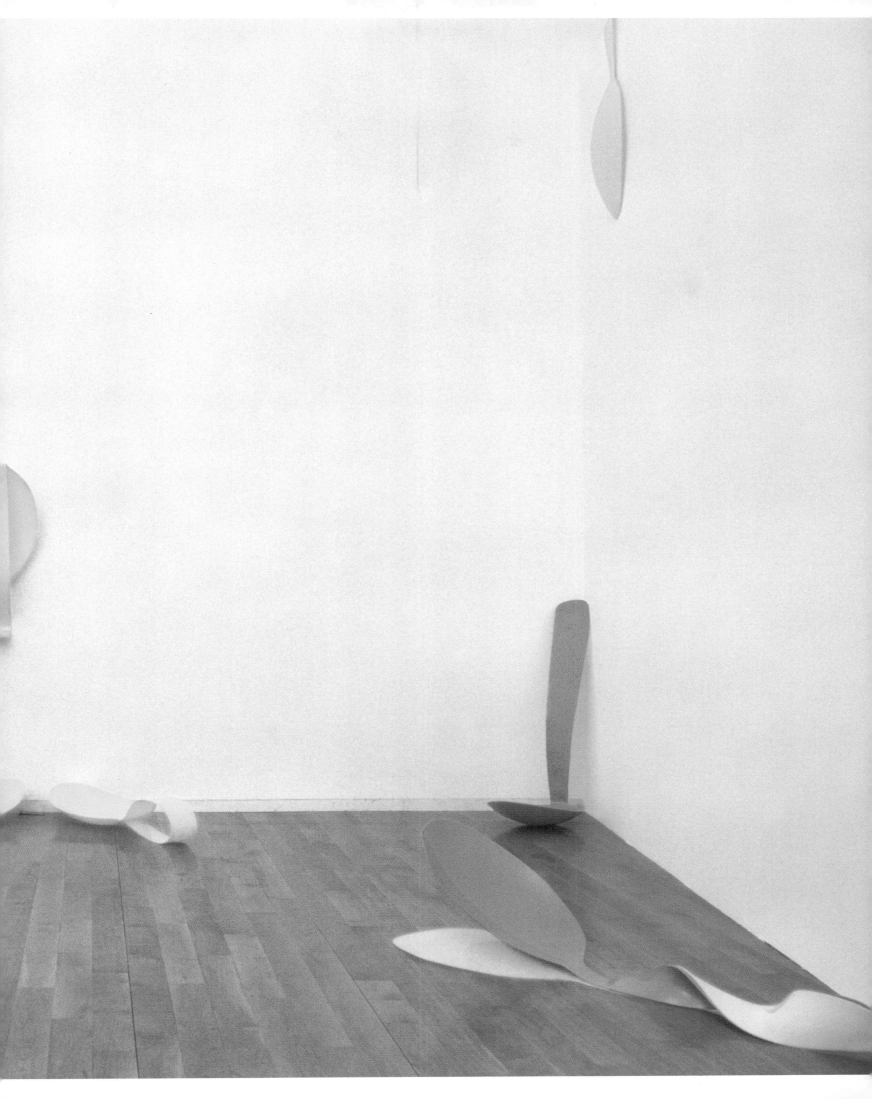

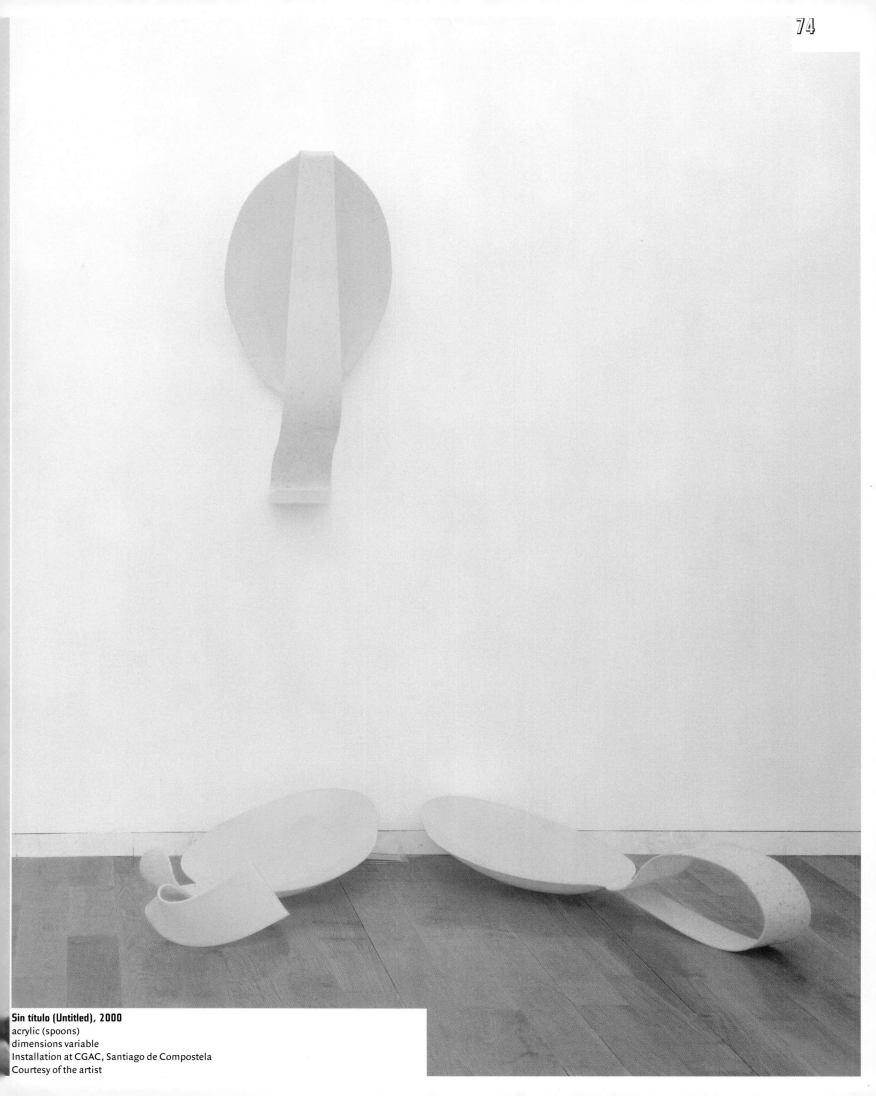

Sin título (Untitled), 2000
acrylic (spoons)
dimensions variable
Installation at CGAC, Santiago de Compostela
Courtesy of the artist

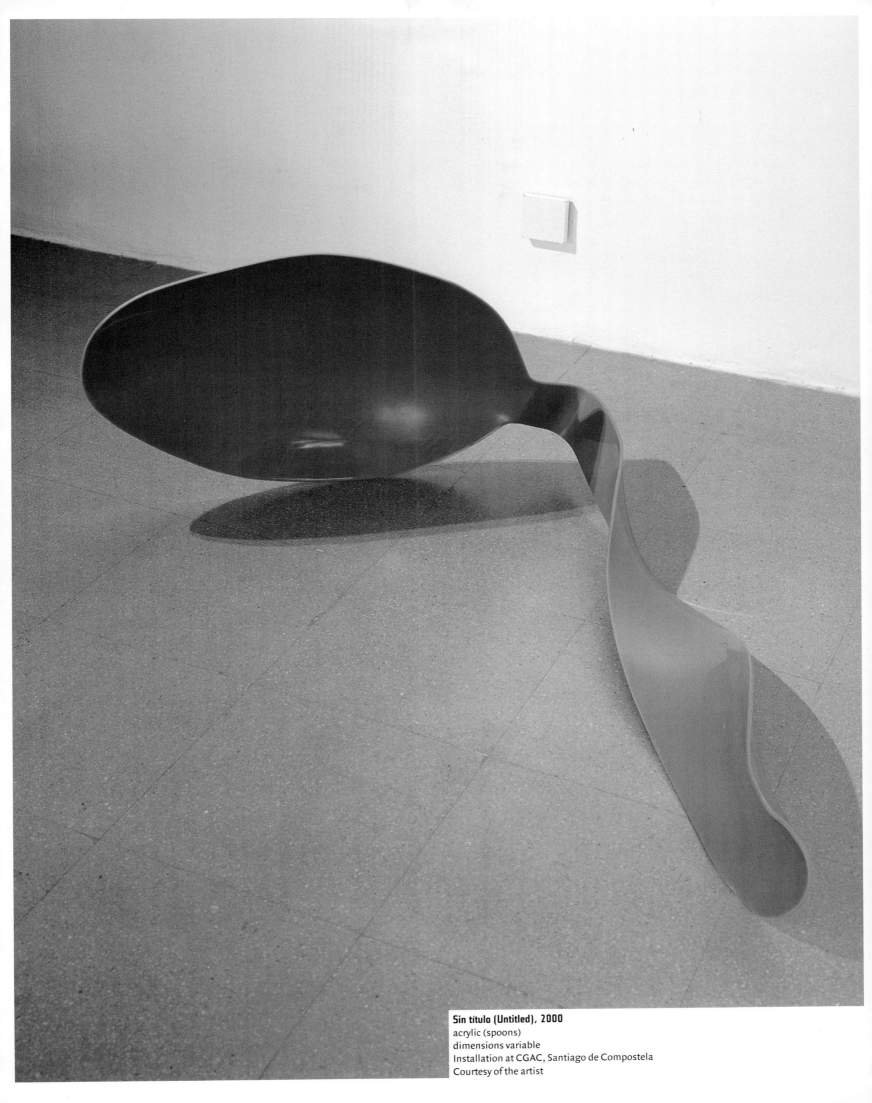

Sin título (Untitled), 2000
acrylic (spoons)
dimensions variable
Installation at CGAC, Santiago de Compostela
Courtesy of the artist

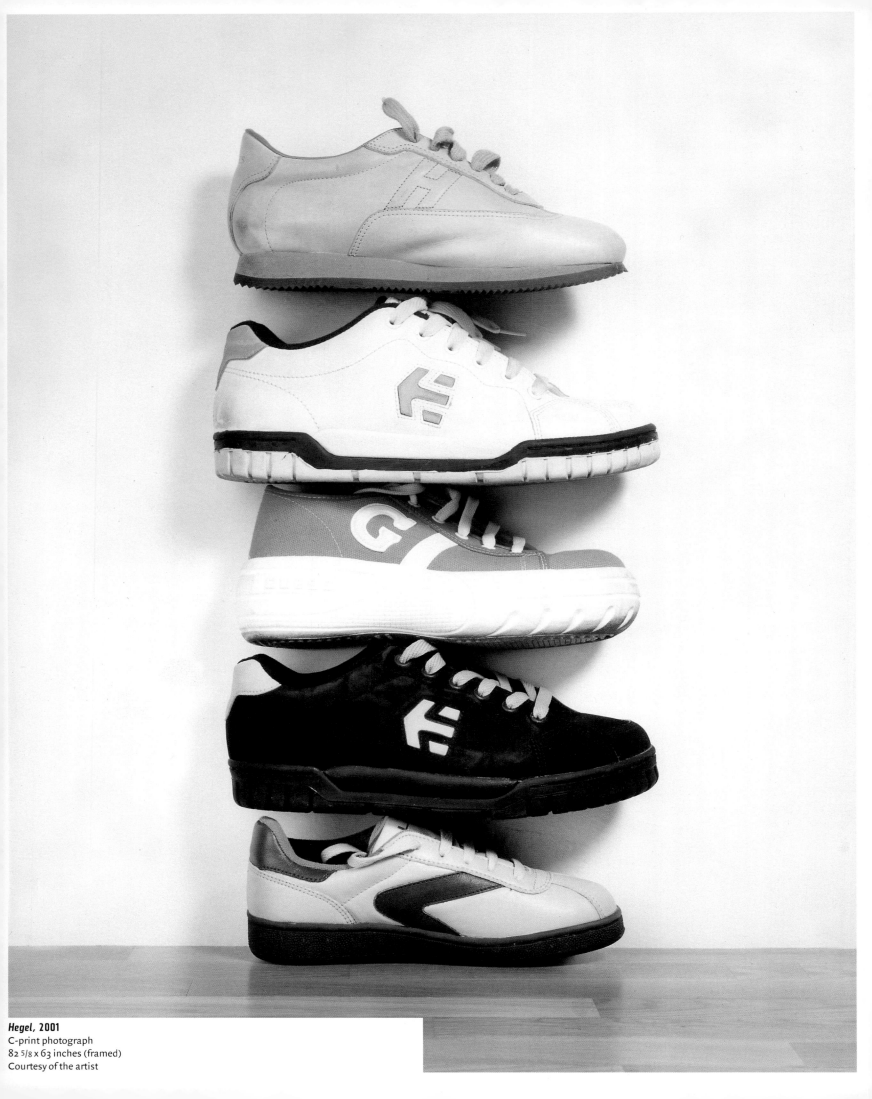

Hegel, 2001
C-print photograph
82 5/8 x 63 inches (framed)
Courtesy of the artist

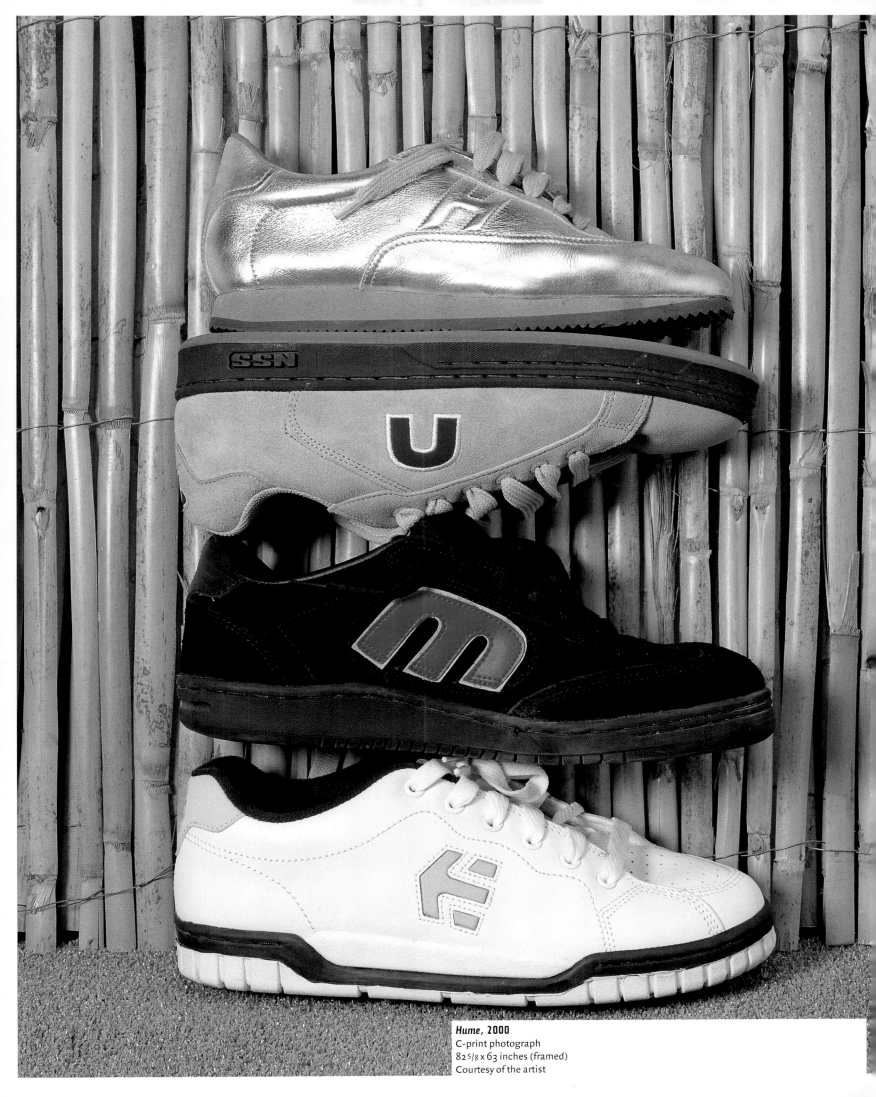

Hume, 2000
C-print photograph
82 5/8 x 63 inches (framed)
Courtesy of the artist

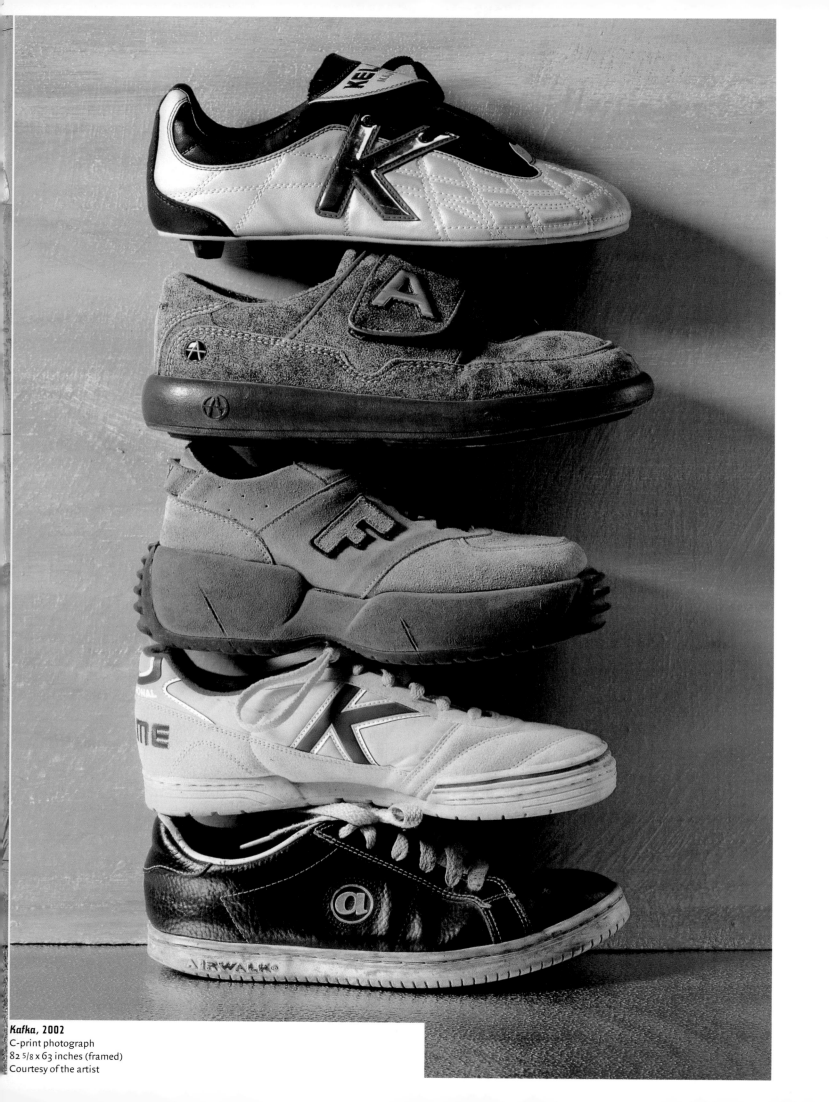

Kafka, 2002
C-print photograph
82 5/8 x 63 inches (framed)
Courtesy of the artist

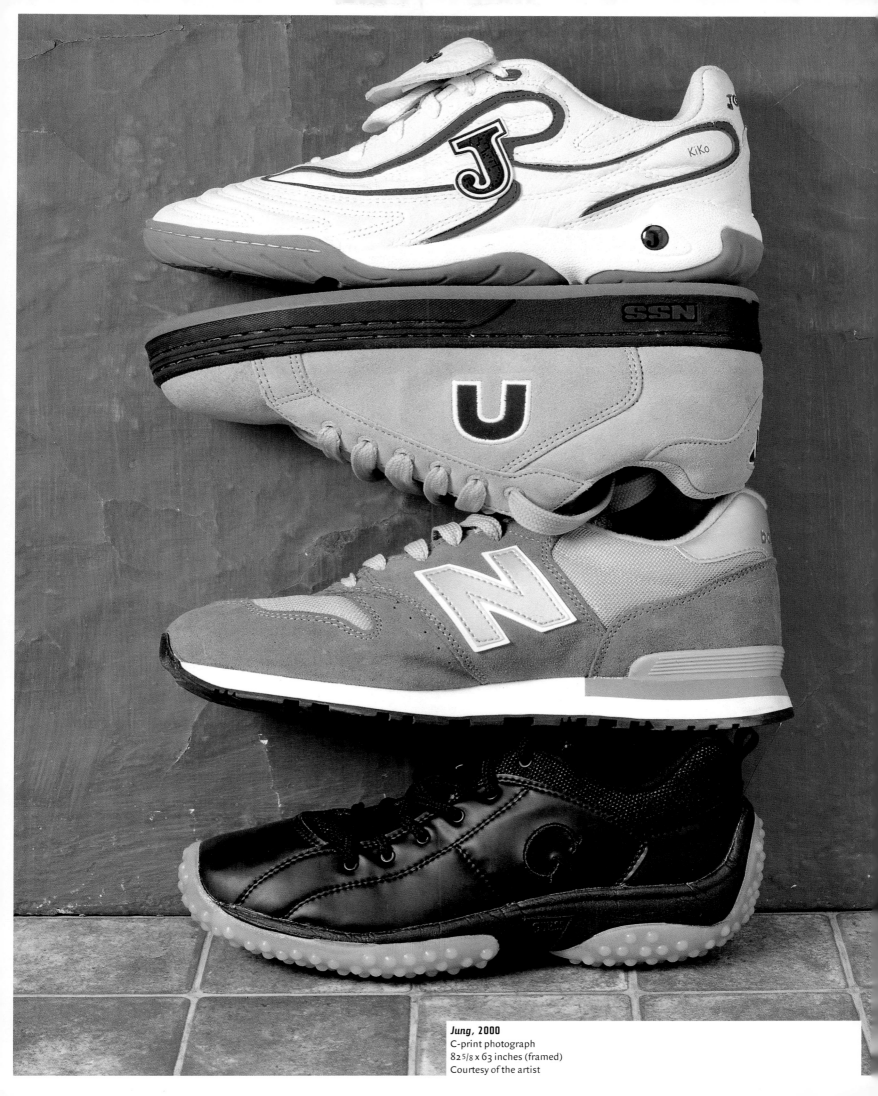

Jung, 2000
C-print photograph
82 5/8 x 63 inches (framed)
Courtesy of the artist

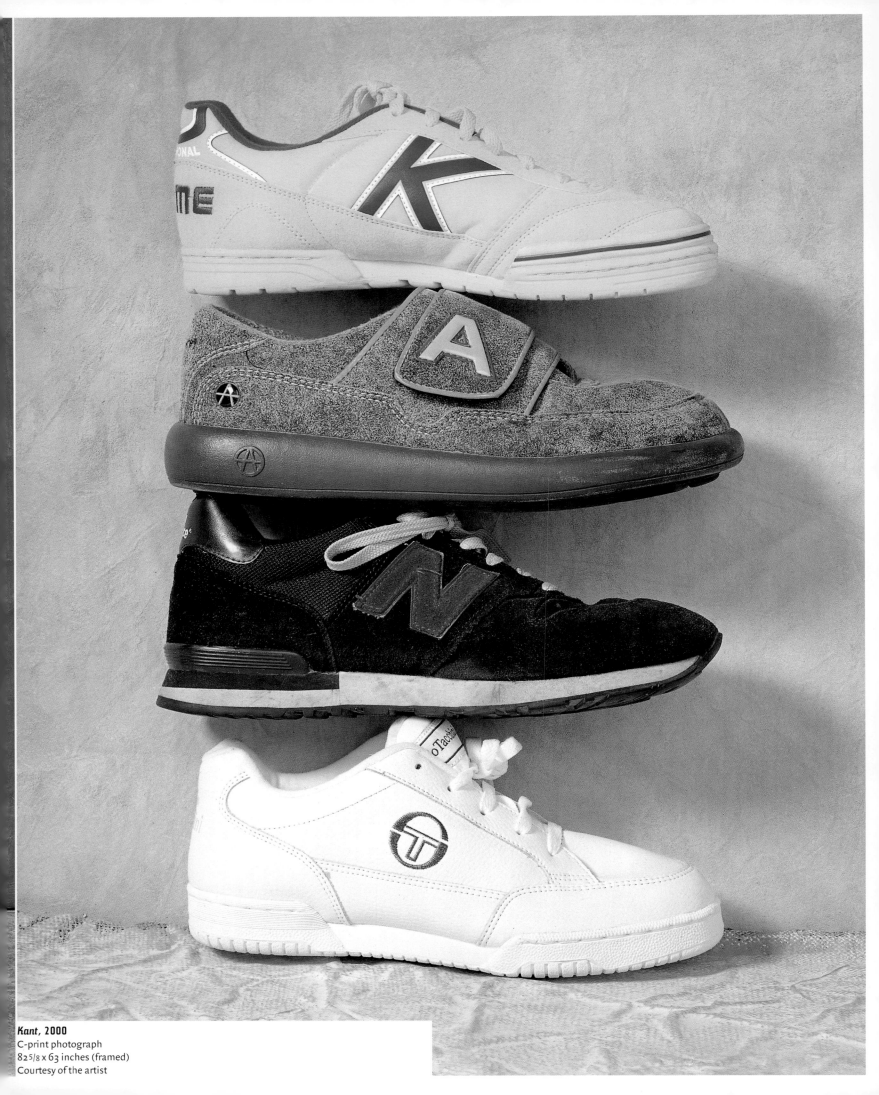

Kant, 2000
C-print photograph
82 5/8 x 63 inches (framed)
Courtesy of the artist

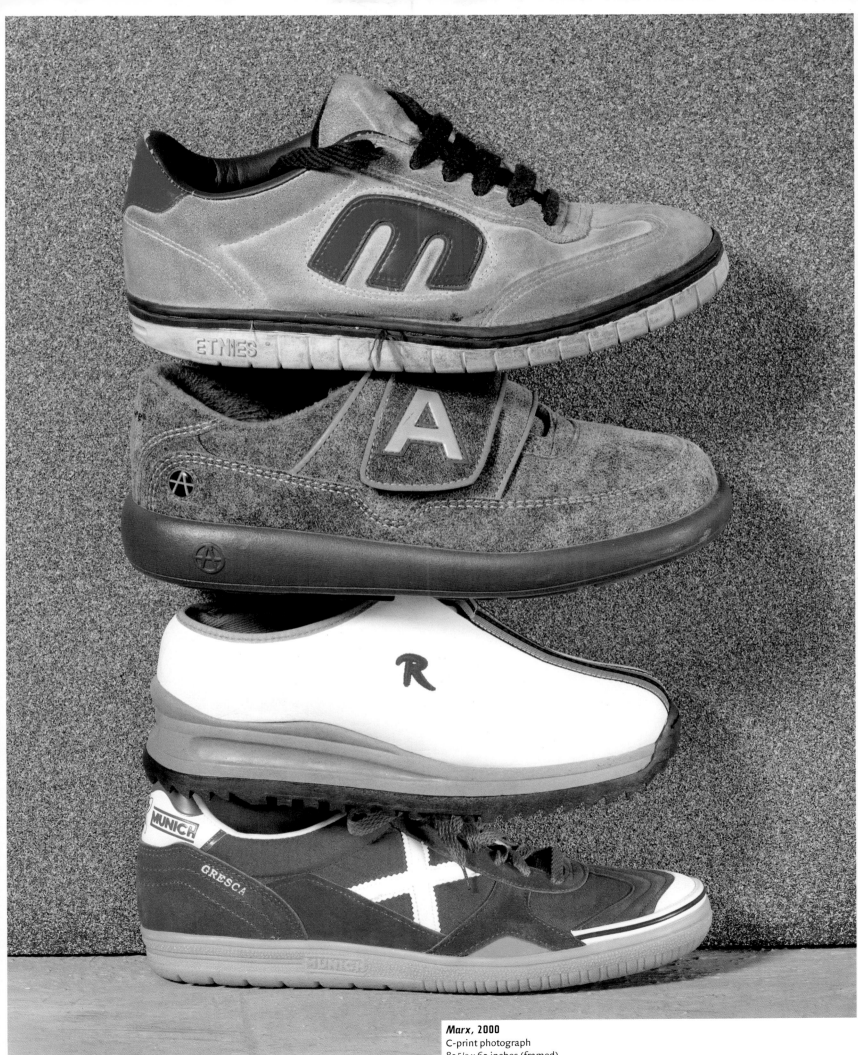

Marx, 2000
C-print photograph
82 5/8 x 63 inches (framed)
Courtesy of the artist

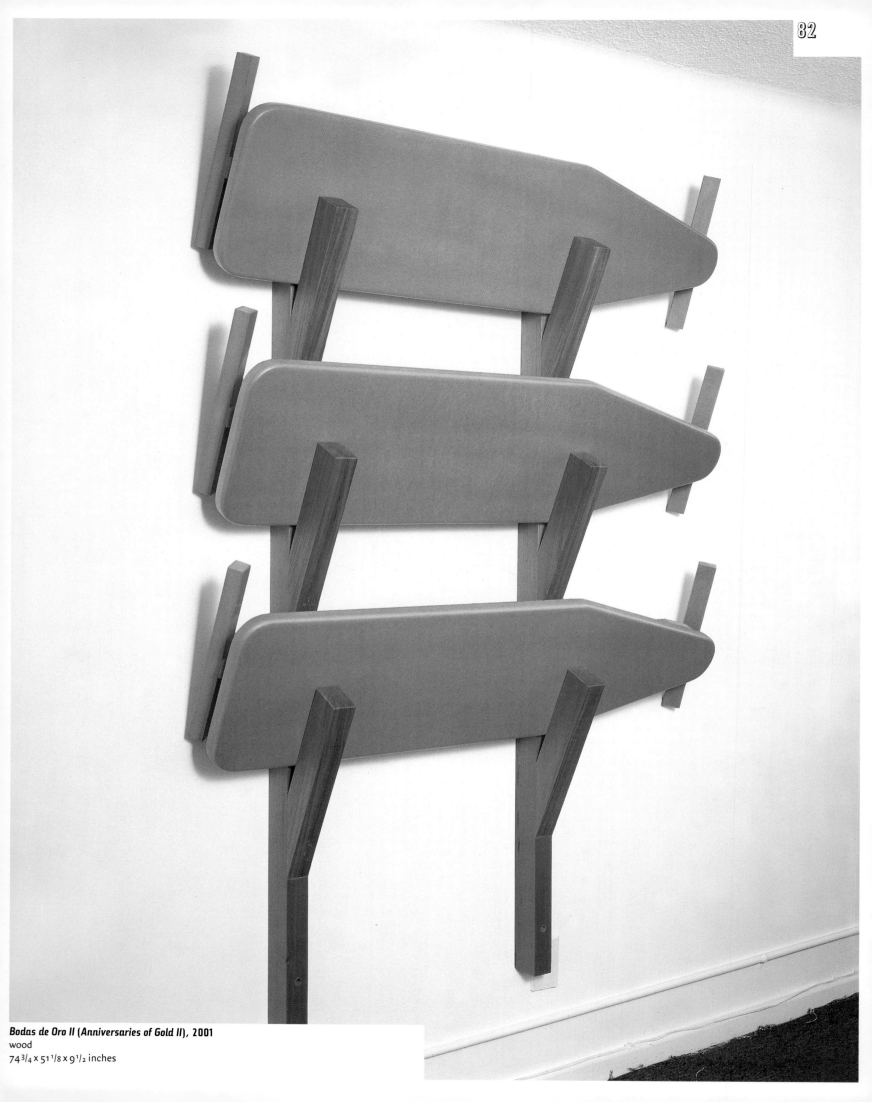

Bodas de Oro II (Anniversaries of Gold II), 2001
wood
74³/₄ x 51¹/₈ x 9¹/₂ inches

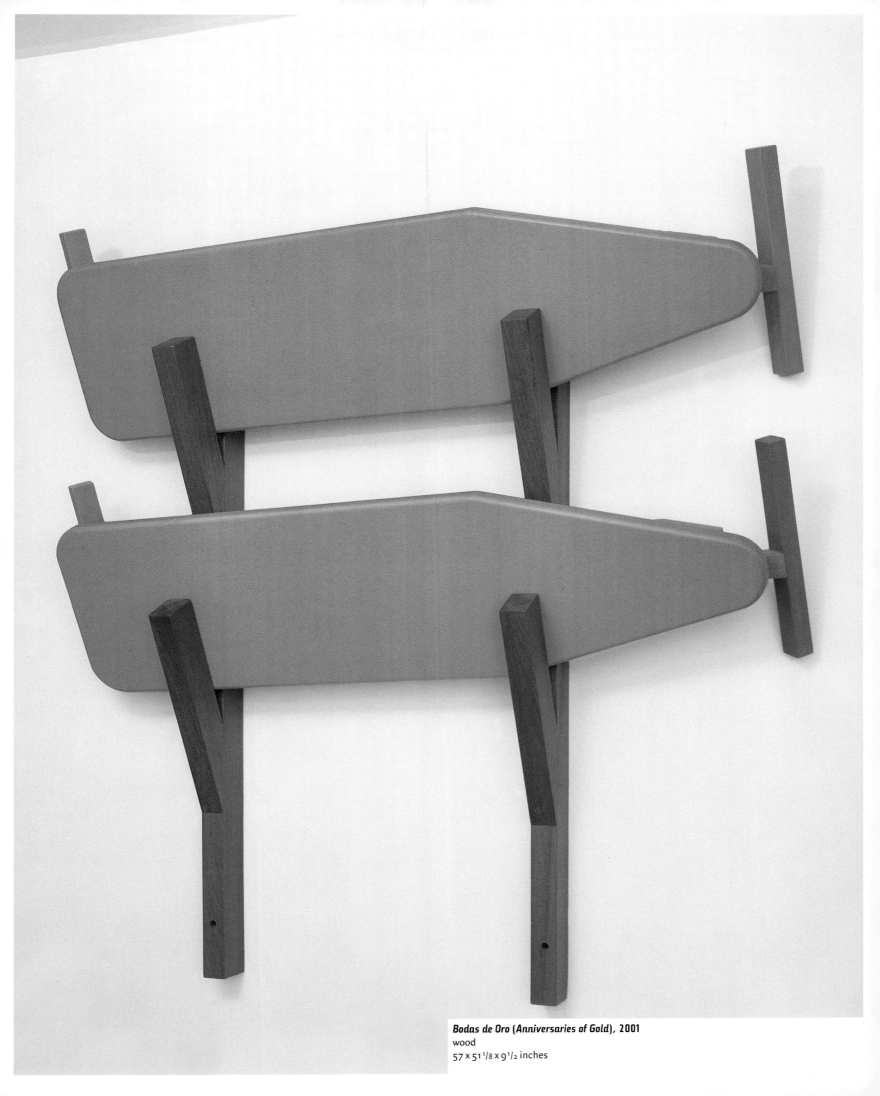

Bodas de Oro (Anniversaries of Gold), 2001
wood
57 x 51 1/8 x 9 1/2 inches

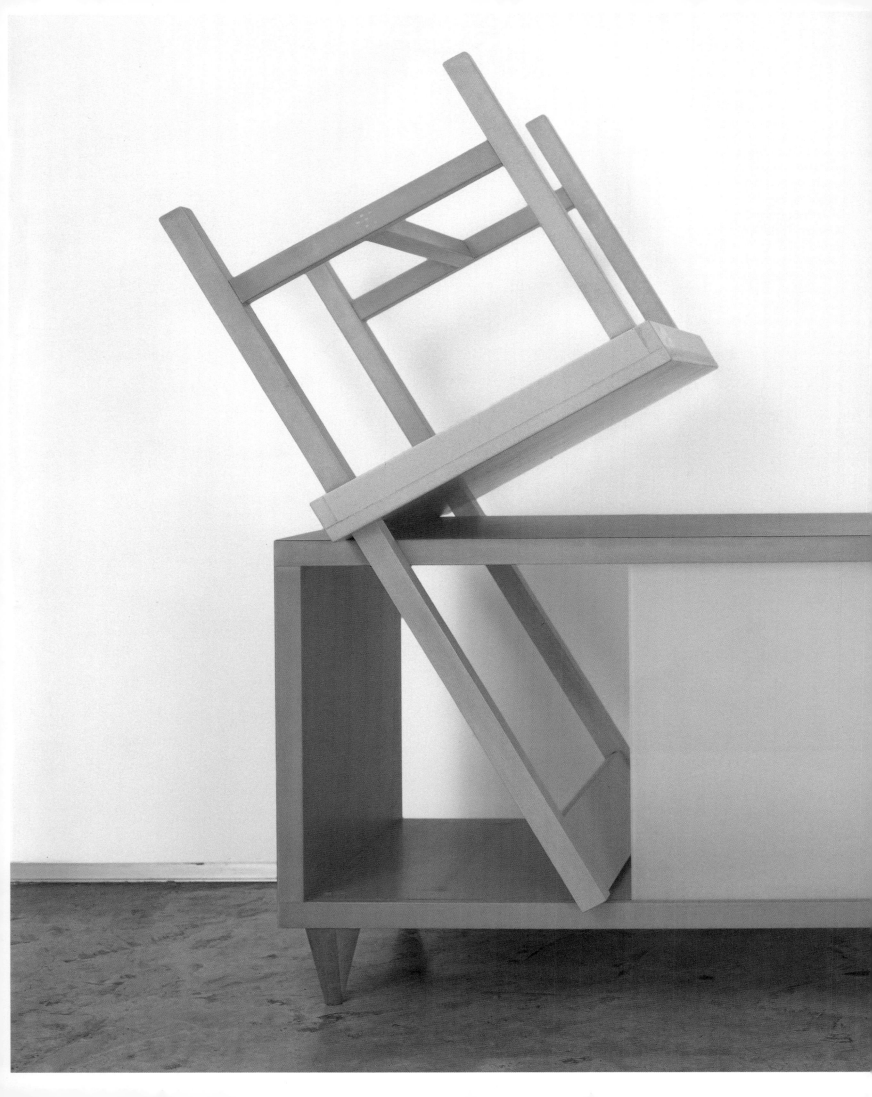

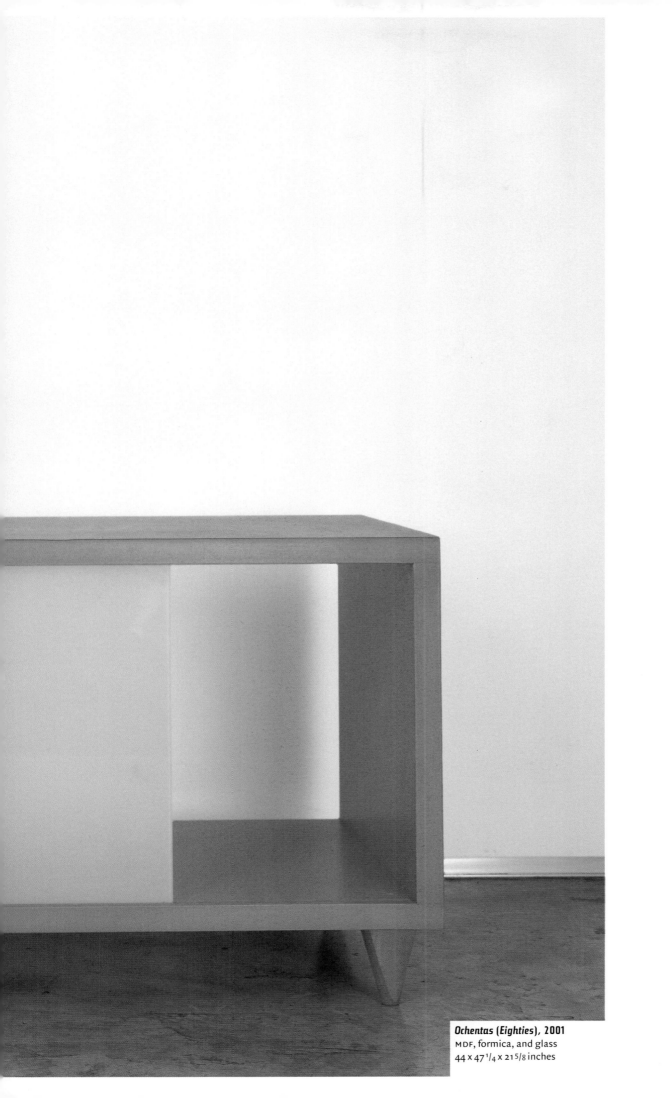

***Ochentas (Eighties)*, 2001**
MDF, formica, and glass
44 x 47 1/4 x 21 5/8 inches

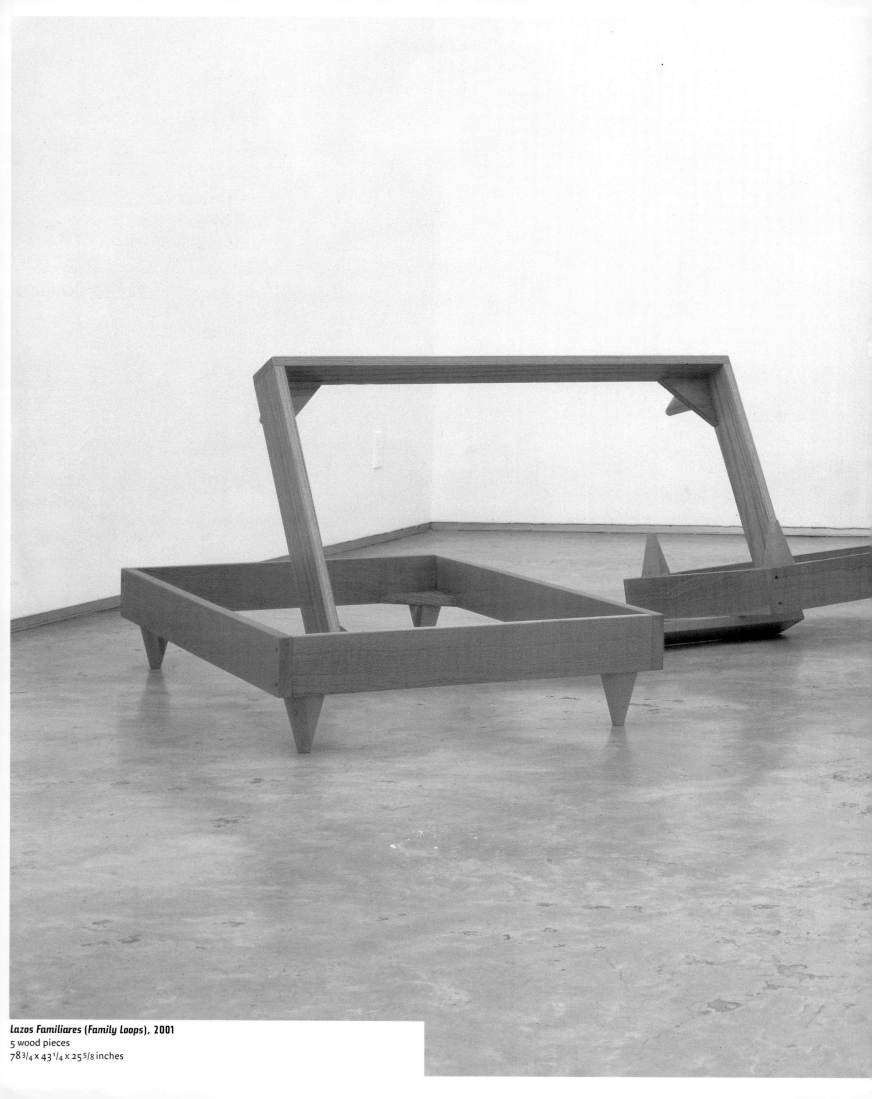

Lazos Familiares (Family Loops), 2001
5 wood pieces
78 3/4 x 43 1/4 x 25 5/8 inches

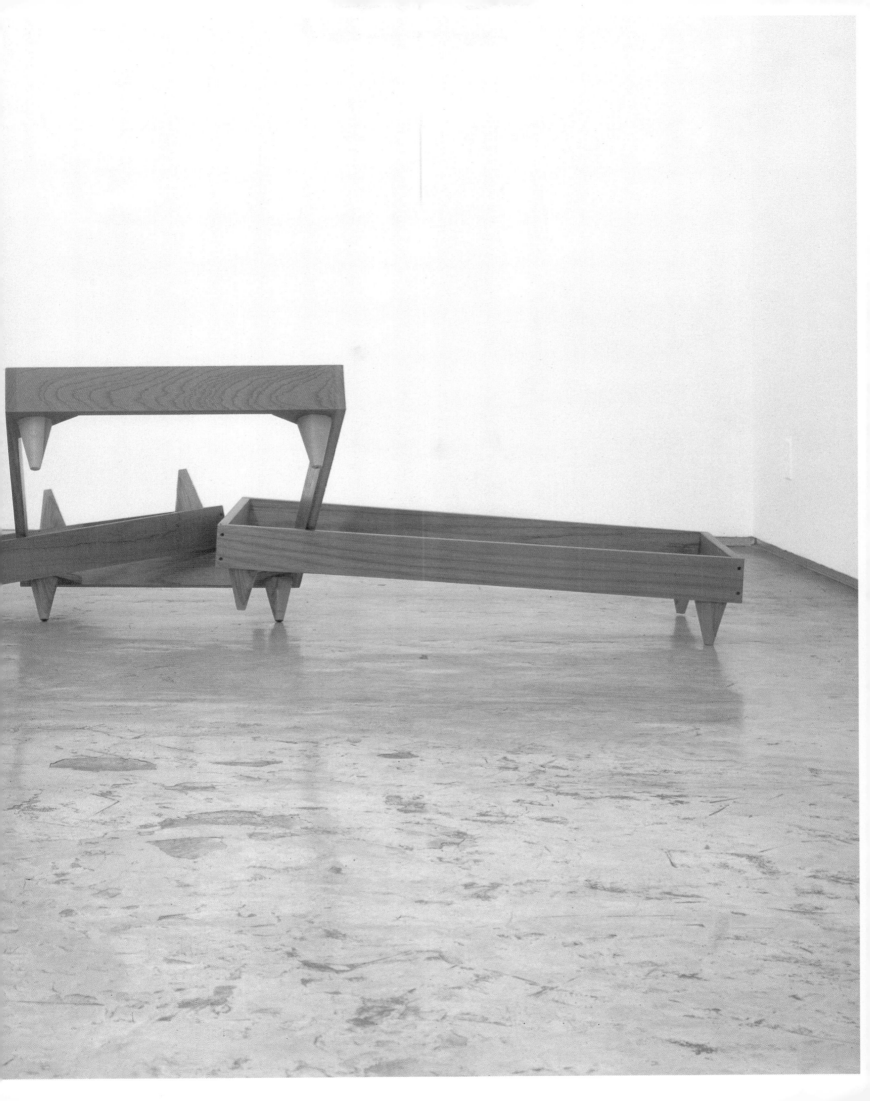

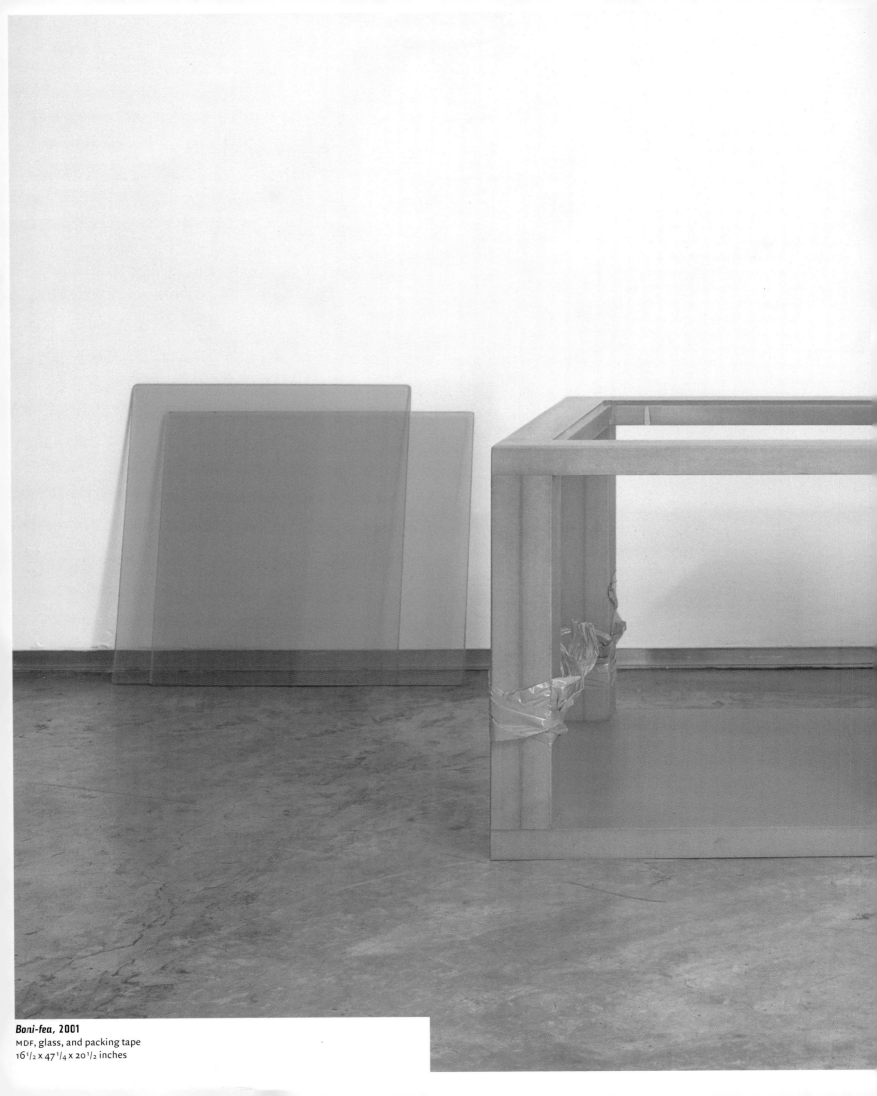

Boni-fea, 2001
MDF, glass, and packing tape
16¹/₂ x 47¹/₄ x 20¹/₂ inches

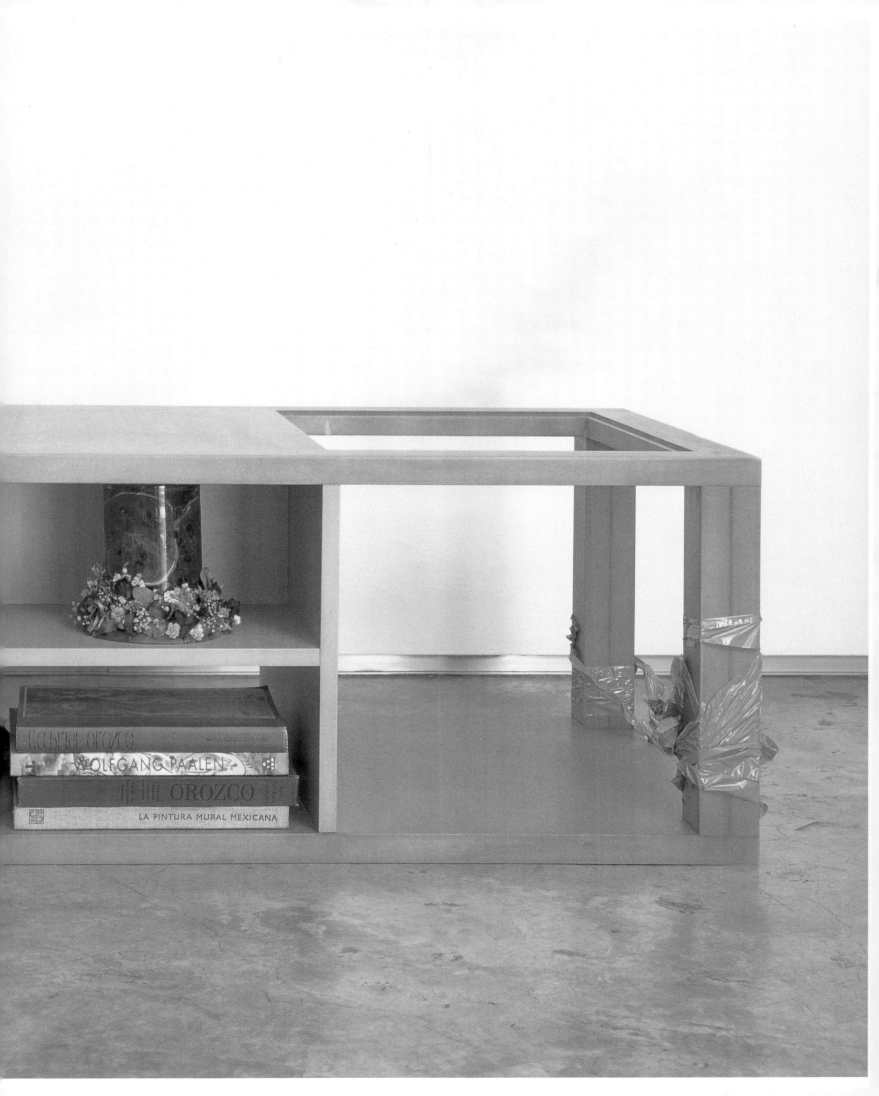

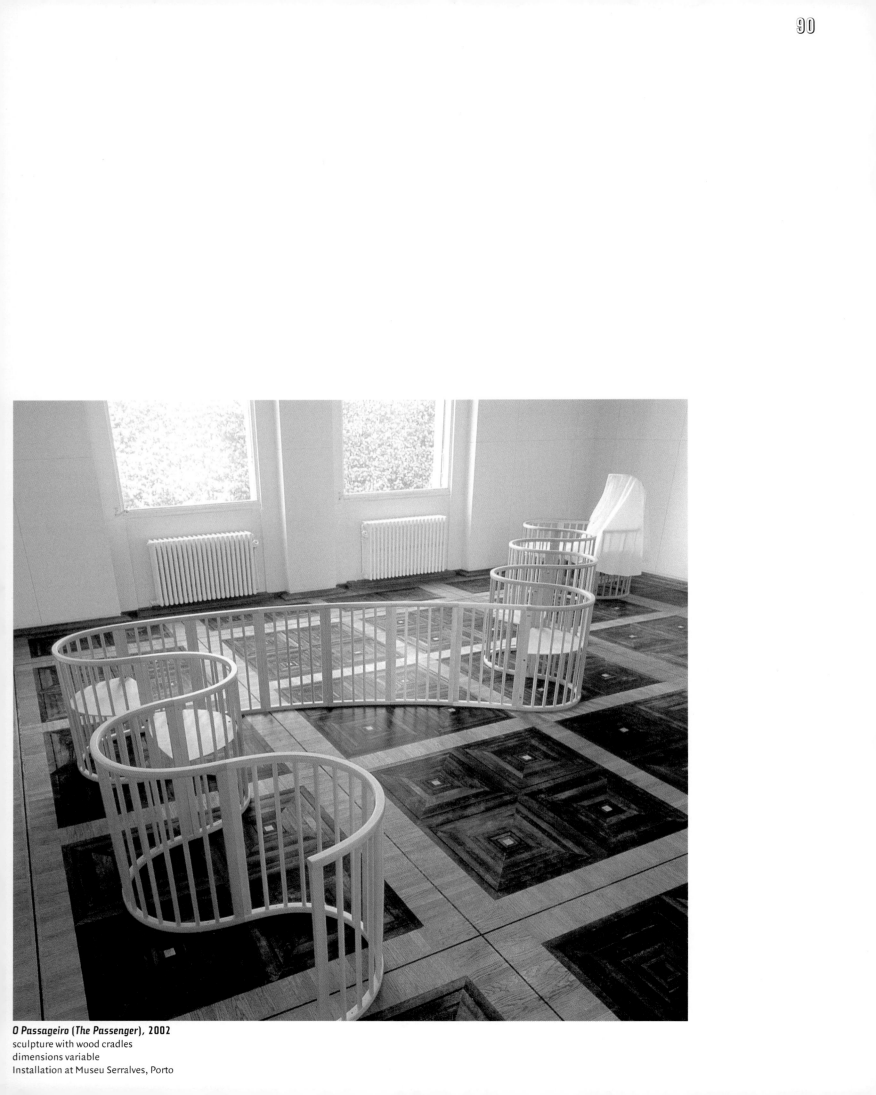

O Passageiro (The Passenger), 2002
sculpture with wood cradles
dimensions variable
Installation at Museu Serralves, Porto

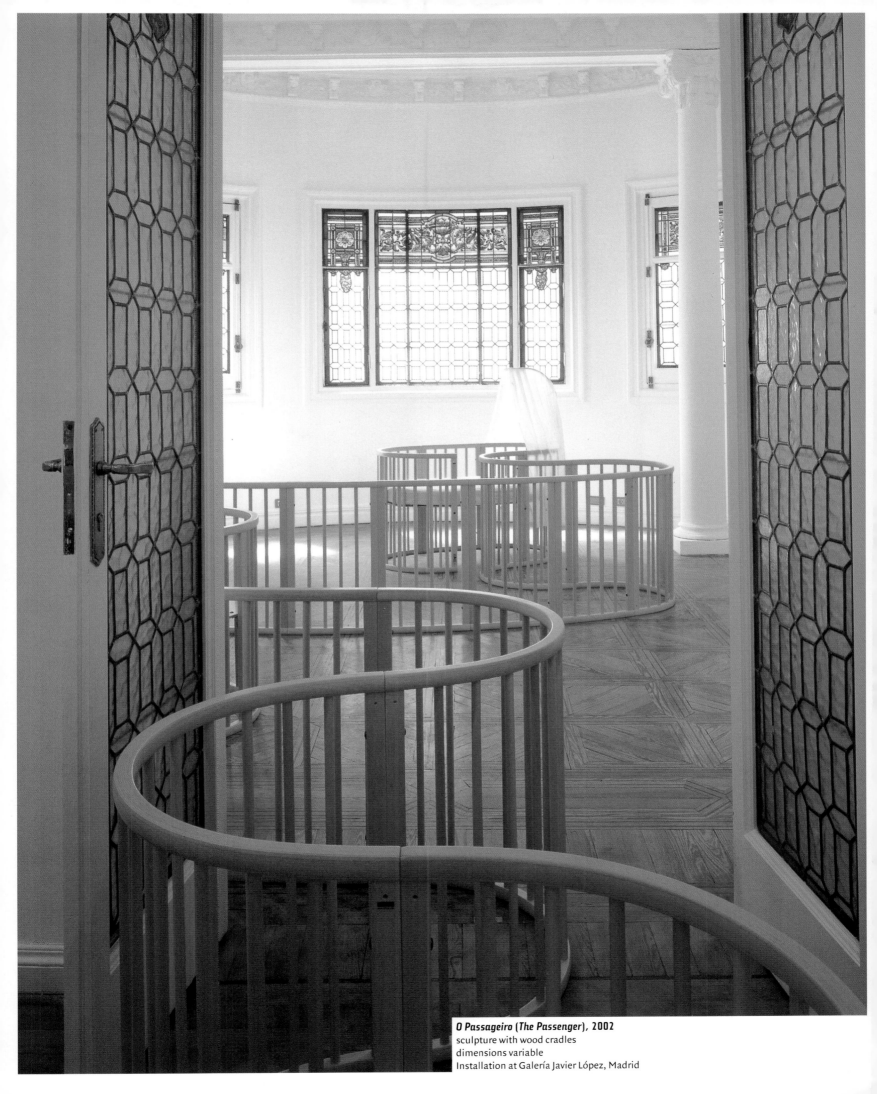

O Passageiro (The Passenger), 2002
sculpture with wood cradles
dimensions variable
Installation at Galería Javier López, Madrid

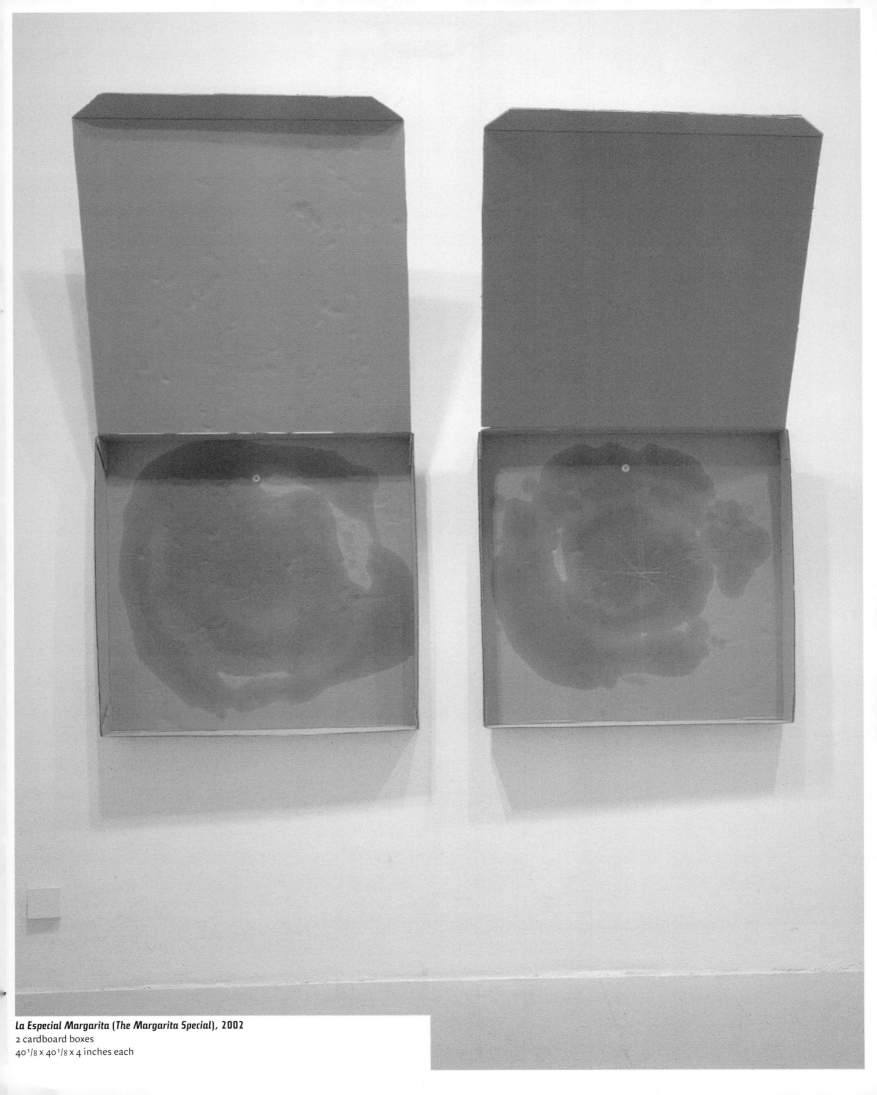

La Especial Margarita (The Margarita Special), 2002
2 cardboard boxes
40¹/8 x 40¹/8 x 4 inches each

***Quatro Sabores (Four Flavors)*, 2002**
1 cardboard box
40¹/8 x 40¹/8 x 4 inches

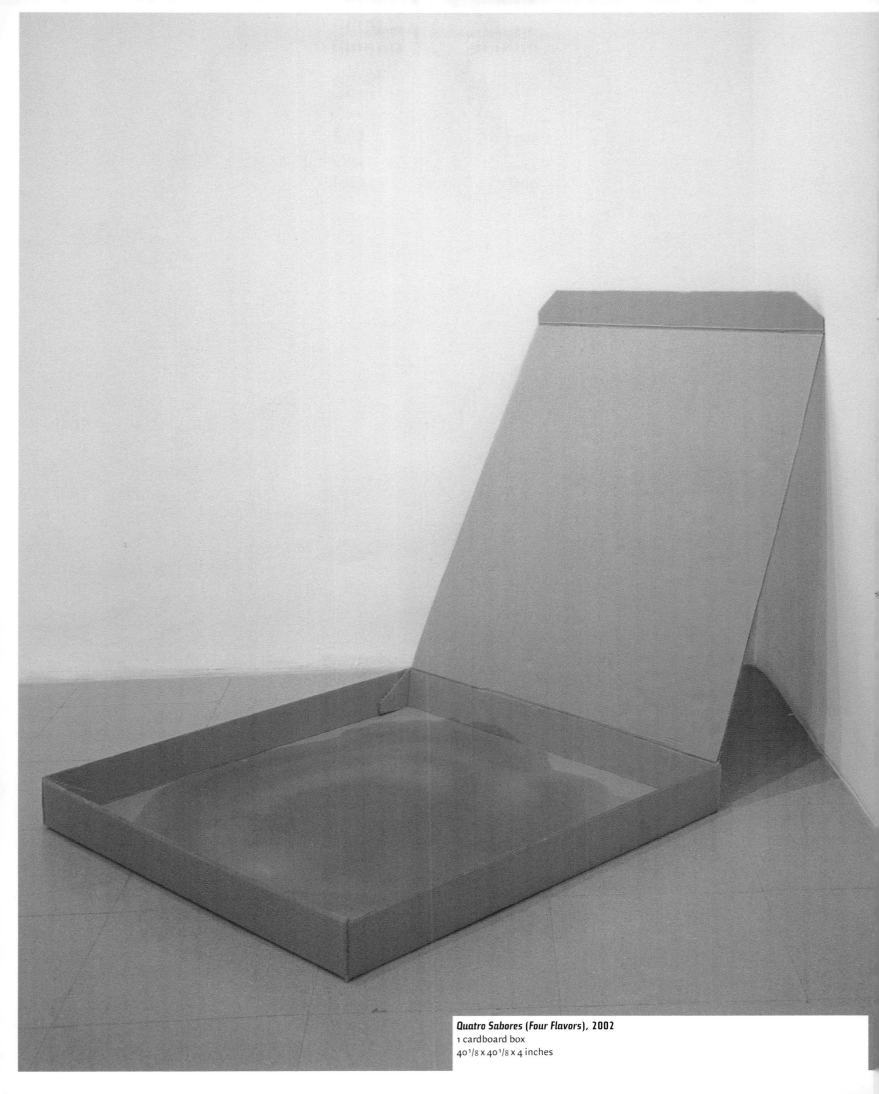

Quatro Sabores (Four Flavors), 2002
1 cardboard box
40¹/8 x 40¹/8 x 4 inches

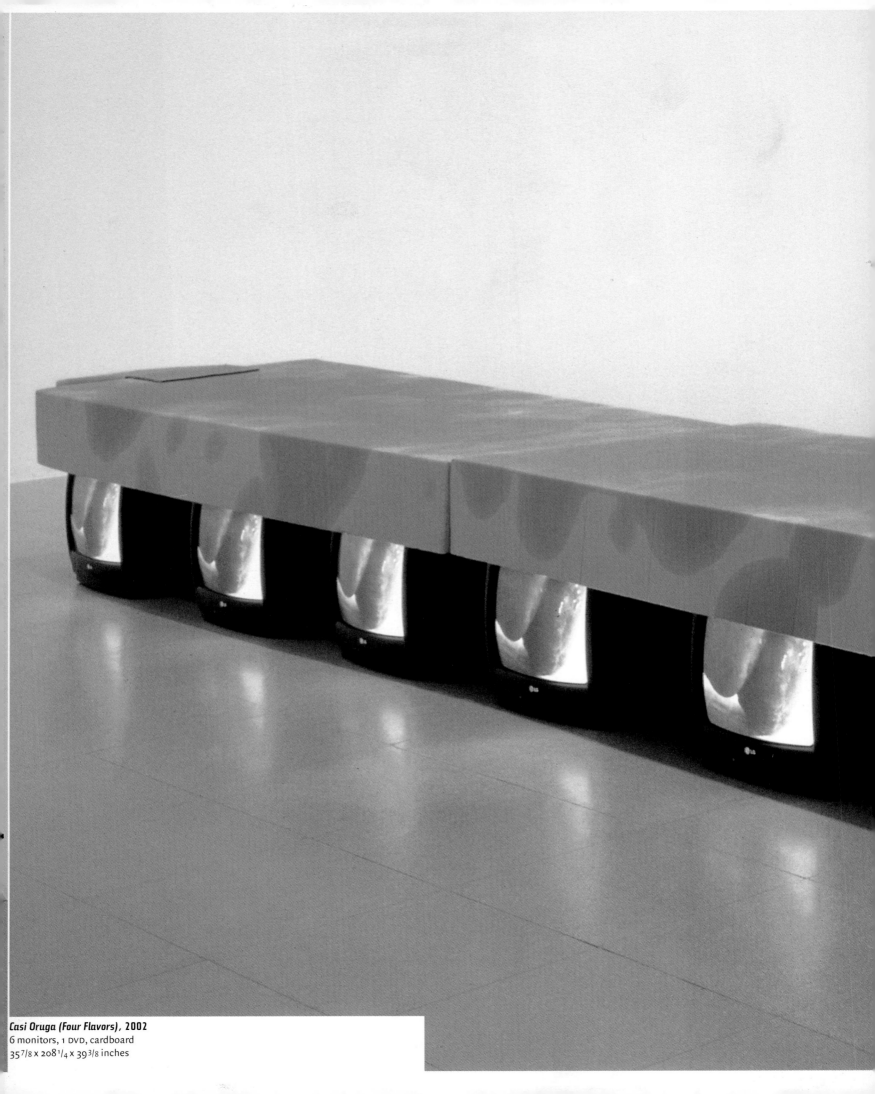

Casi Oruga (Four Flavors), 2002
6 monitors, 1 DVD, cardboard
35 7/8 x 208 1/4 x 39 3/8 inches